Taller Than Trees

Taller Than Trees

To my daughters, Catherine and Meredith,
and to all the New Yorkers who find themselves freer in our parks.

Taller Than Trees

Studio 96
LIVE IMAGES

Publications by Studio 96 Publishing contain Live Images, or images that unlock digital layers in augmented reality dispersed throughout the book. To begin, scan the QR code to download the S96 app.

Every time you see the ⊡ symbol on a page in this book, point the camera in your S96 app towards the page and scan the image, then watch it come to life.

Table of Contents

Taller Than Trees

Foreword

For two decades before Mary Reilly moved to Vermont in 2015, she sought out natural environments in the 28,000 acres of New York City's municipal parks and 14 miles of public beaches. These open-air green spaces are a fundamental necessity for a healthy urban life. They nourish the metropolis and its inhabitants, satisfying the visceral human need to connect with nature, while providing opportunities for recreation (re-creation), socialization, and reflection in an otherwise densely populated locale. Democratically free to all, they also nurture flora, fauna, and avian life—both year-round inhabitants and migrants plying the eastern flyway twice annually. In our era under the threat of climate change, these restorative urban oases have become even more precious.

My first intimate understanding of Reilly's art occurred with *Breezy Point 3* (page 55), created in 2011, a tour-de-force drawing from the time she spent at this Queens neighborhood beach before Hurricane Nicole in 2010. During its nine months of gestation, the artist transformed the exquisite seascape into a nocturnal moonlit scene with a slightly foreboding intimation of the sea's destructive power. In retrospect, the work is both poignant and prophetic. Hurricane Nicole, which brought rough surf and winds to Breezy Point, was but a prelude to the damage wrecked on the area in 2012 by Hurricane Sandy. In light of that devastation, Reilly believed that the drawing belonged in a New York public institution, and she subsequently gifted it to the New-York Historical Society.

Without color and only in a restricted but infinite palette of nuanced grays, Reilly draws haunting works that celebrate close-ups of nature's majesty: flowers, shells, the surfaces of rocks, the roiling surface of the ocean and its eternal rhythms, and ice formations. Each cropped vista consists of a master work of texture and intricate patterns in a concentrated artistic universe: a rich microcosm of the cosmos that intensifies its mysterious beauty.

To create her meticulous studies of nature's splendors, Reilly employs her medium of choice—graphite in both powdered and pencil form—in an intricate and highly personal manner of working. Preferring Coventry Smooth paper as a support on which to layer her hallucinatory images, "I tone my paper with up to eight layers of graphite before laying in my initial drawing, taking the surface to a middle tone then pushing the darks with pencils and lifting the lights with erasers," Reilly explains. Her tools for this magical process are readily available graphite pencils (Toison D'Or and Tombow) for the darks and a variety of erasers, including a vinyl one which she sharpens, to pick out minute highlights. To blend the pencil strokes, she utilizes tortillons, or paper stumps, and enlists chamois cloth for the toning stage. "This process creates subtle shifts in the tone that are in harmonious contrast with the sharpness of the minute details," she relates, "helping me create a sensuality and a mood in each piece." At once additive and subtractive, this process allows Reilly to explore the full range achievable in a gray-scale palette.

Above all, it is in her drawings of trees, many denizens of New York City's parks, where Reilly's drawings attain aesthetic heights. The Nature Conservancy counts more than seven million trees that make up New York City's treasured urban forests across all five boroughs. Reilly's drawings of trees are heirs to trees drawn by many Old Master and nineteenth-century Romantic artists. Chief among them is the magnificent obsession of the master

Taller Than Trees

draftsman of the so-called Hudson River School painters, Asher B. Durand. His repository of works in the New-York Historical Society includes over 250 independent drawings and 373 sketchbook studies of trees, mostly rendered in graphite. Whether foreshortened views of skeletal wintry trees stretching skyward minus their canopy crowns, or truncated vistas of a network of tree trunks, Reilly's arboreal drawings hint mysteriously at the macrocosm of nature and invite the viewer to enter and to complete the scene. One senses in the artist's poetic portrayals of trees their interconnectivity, as well as their individuality.

Reilly's trees find a parallel in the winner of the 2019 Pulitzer Prize in Fiction, *The Overstory* by Richard Powers, an evocation of—and paean to—the inner lives of trees that unfolds in concentric rings of interlocking fables. Like Reilly's drawings, the book sings about a world alongside ours—vast, slow, interconnected, resourceful, magnificently inventive, and threatened. Another soulmate of Reilly's is the tree whisperer and German forester Peter Wohlleben, whose best-selling book is *The Hidden Life of Trees: What They Feel, How They Communicate*. Like him, Reilly's tree drawings seem to answer the question: do trees talk to each other? For Reilly and the writers, trees are sentient and communal beings that are vibrantly alive and charged with wonder. By communicating with one another, they are involved in tremendous struggles and death-defying dramas that depend on a complicated web of relationships, alliances, and kinship networks. They thrive in a "wood wide web" of chemical, hormonal, and slow-pulsing electrical networks, sometimes for hundreds of years to produce many offspring and to attain dizzying heights.

After drawing trees in the North Woods of Central Park, Reilly decided to research and explore the parks in the other four boroughs. "To my surprise, I discovered that there are beautiful ancient forests here, with magnificent old trees. There are winding rivers, streams, creeks and marshes, as well as lakes and ponds, and miles of sand dune filled beaches." As a result, she embarked on her *Graffiti Trees* series, most of whose images she discovered in the woods of Alley Pond Park in Queens, which has one of the most ancient forests in New York City.

"I photographed "graffiti" trees in many parks within the five boroughs of New York, but the trees in Alley Pond Park were by far the most plentiful and the most interesting, with carvings dating back to the 1930's, as in "Jack Loves Kat" from 1932 (*Jack Loves Kat,* 2013, page 80). What I find interesting about these woods is that the carvings are all so different. Walking through the woods was like a trip back in time. Almost every tree had something carved on it which made me imagine the people from the surrounding neighborhoods walking into the park, whether it be kids drinking, smoking and hanging out, or lovers taking a stroll. I found the faceless initials carved on the trees and what might be the story behind them to be most interesting. I guess you can say that the history of the carvings is what inspired me to draw them," said Reilly.

Since the advent of recorded history, graffiti has existed as a form of urban street writing or "tagging." But with trees, the maker's tag consists of carving into the surface of the bark, like an intaglio print, not painting or drawing on its surface. Thereafter the maker's mark is subjected to the tree's fight to survive by healing this wound: there is

no controlling what will happen as the tree seals the open sore and the bark organically grows around it. As Reilly's drawings demonstrate, the makers remain anonymous urban renegades, whose identities tease and testify to the diversity that is the melting pot of New York.

Reilly found *PeeWee* (2015, page 113)—a work that the New-York Historical Society purchased—in what is now called the Thain Family Forest, formally known as the "Historic Forest," in the New York Botanical Garden in the Bronx. For thousands of years, this old-growth forest has changed, adapted, and survived. Upon visiting, you walk along Indigenous American hunting trails under trees alive during the American Revolution, and see gouges left by glaciers. The area's ecological importance is one of the reasons why the founders of the New York Botanical Garden selected this site in 1895. Today, it is the largest uncut expanse of New York's original wooded landscape and remains a reminder of nature's resilience in the face of human-caused inroads.

"PEE WEE" is the ambiguous tag of an early adolescent graffiti writer, who probably lived near this wildlife sanctuary; the full inscription appears to contain more information and a play on words reading PEE WEEP. Its anonymous writer may have been a person of small stature with that nickname, who was sad about being petite. Alternatively, the "P" may have been the first letter of the writer's surname, adding another element of mystery to the sheet. Not only does the work have a dialogue with New-York Historical's Durand and graffiti art collections, including works by Keith Haring, it also recalls many watercolors by John James Audubon for *The Birds of America* that feature trees. Coincidentally,

Audubon named one of his favorite species the "Peewee Flycatcher." Today, the species is known as the Eastern Phoebe. Audubon applied silver threads to the legs of individuals of this species, becoming the first person in history to practice bird banding, which for me evoked the silvery tonalities of Reilly's graphite in the tree bark of her drawings, as well as the gray plumage of the bird.

As with so many other artists who have lived in or visited New York, the city's parks have served as an inspiration for Reilly's unique works. Instead of creating topographical landscapes or cityscapes or works to embellish the parks' paths—from bronze sculptures to Christo's and Jean-Claude's "The Gates"—Reilly zeroes in on small slices of stunning beauty that become universal statements.

Roberta J.M. Olson, Ph.D.
Curator of Drawings
New-York Historical Society Museum & Library

Mary Reilly

New York native Mary Reilly is an artist of the wide earth. Her sense of freedom while exploring the outdoors is channeled into her large-scale, hyper-realistic graphite drawings. These detailed black-and-white portraits of nature are diverse, spanning throughout New York City's five boroughs, where Mary gives voice to the unexplored havens within the state's lakes and forests. Indeed, these profound depictions of nature lie beyond one's passing glance. Magically, the infinite facets of forests are bound to her silky page. In Mary's artwork, we feel the earth's power and are exposed to the wonders of traveling by foot.

"Having lived in New York City for more than twenty years, and after having found the natural oasis within the North Woods of Central Park, I decided to research and explore the other four boroughs. To my surprise, I discovered that there are beautiful ancient forests here, with magnificent old trees. There are winding rivers, streams, creeks and marshes, as well as lakes and ponds, and miles of sand dune-filled beaches. This work represents some of the natural beauty from the boroughs of New York City that too few get to appreciate. My sense, both emotionally and visually, of New York City's natural side is forever changed, and I hope my work changes your impressions too."

—Mary Reilly

Mary's
Parks

Map / 01

This map indicates the parks
Reilly visited and whose nature
she drew.

Taller Than Trees

16

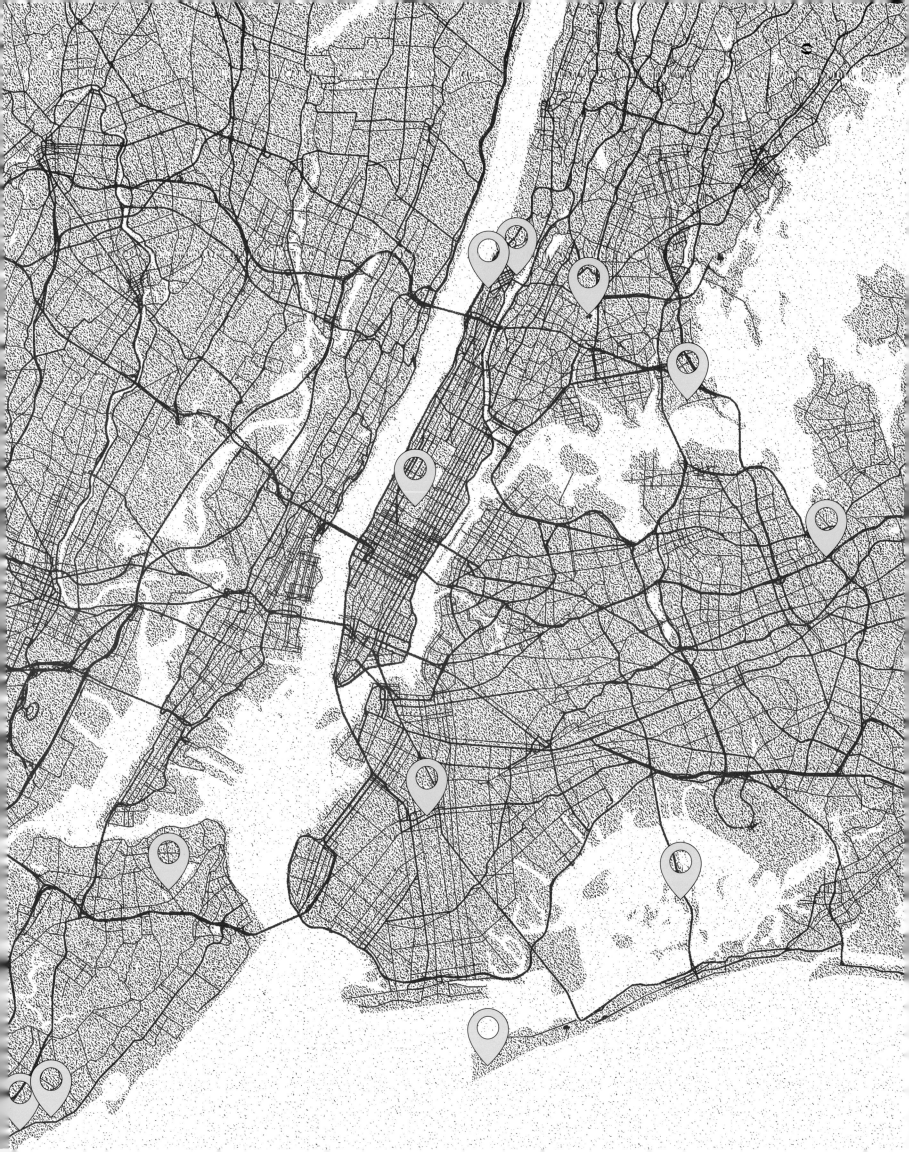

Daylight

slants like a razor cutting the buildings in half. In the top half I see looking faces and it's not easy to tell which are people, which are the work of stonemasons. Below is shadow where any blasé thing takes place: clarinets and lovemaking... A city like this one makes me dream tall and feel in on things...It's the bright steel rocking above the shade below that does it. When I look over strips of green grass lining the river, at church steeples and into the cream-and-copper halls of apartment buildings, I'm strong. Alone, yes, but top-notch and indestructible—like the City in 1926 when all the wars are over and there will never be another one. The people down there in the shadow are happy about that. At last, at last, everything's ahead. The smart ones say so and people listening to them and reading what they write down agree: Here comes the new. Look out. There goes the sad stuff. The bad stuff. The way everybody was then and there. Forget that. History is over, you all, and everything's ahead at last.

— *Toni Morisson, Jazz*

Manhattan

Chapter / 01

The supreme irony of Manhattan is that its most coveted dwellings are those that make you feel outside out of it: penthouses with views of Central Park's lucious tree tops, luxury condos whose windows reflect the cool, running Hudson. Life in the world's center is made possible only because of its nature. Muse as teenagers dare to flirt under the arch in Washington Square Park, en route to their fuller identities. Go deeper into Central Park's Ramble until you look up and can see no buildings, only leaves. You could be in the Adironacks. Or the Catskills. Or Vermont. But you're not. This nature is special because it's here, in the heartbeat of planet Earth.

Central Park

During such peaceful moments of traversing the Park, it is hard not to be jolted into its grandeur. Frederick Law Olmsted and Calvert Vaux, the architects of Central Park, were calculated in their craft, gifting an industrial city with some finite foliage, but the feeling of an infinite world.

What makes Central Park special? Certainly, it is the fanfare of amber leaves that appear in October. It is the wildlife that thrives. It is the sight of families sledding, and an older sister showing her brother the best way up a hill. These same children will soon do cartwheels in the summer grass, with popsicle-stained faces. They'll learn what bugs are what bugs, and stand together with grown-ups who are so much older than they can imagine.

In Central Park, and New York City, passion grows like a vine, and as the years pass, you are not just older but more devoted.

"The enjoyment of scenery employs the mind without fatigue and yet exercises it; tranquilizes and yet enlivens it; and thus, through the influence of the mind over the body, the effect of refreshing rest and reinvigoration to the whole system."

-Frederick Law Olmsted

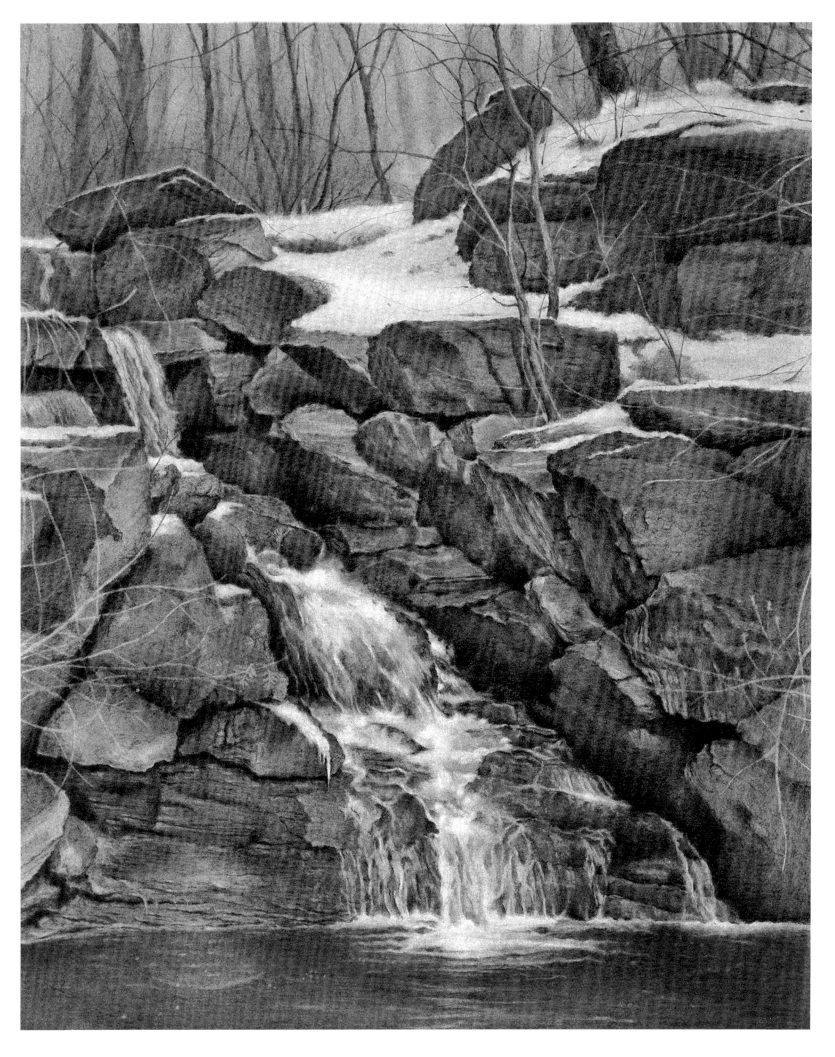

Glen Span Arch

What echoes under the Glen Span Arch, marking the southern edge of Central Park's North Woods? What sound rushes like the Loch, into the shaded tunnel atmosphere? Man's footsteps patter through this copied cave, each stride attesting that outdoor adoration is ingrained in our human bones.

The bones of this bridge are sturdy, its geometric boulders drawn from the surrounding woodlands, and forming an underpass that is a quintessential part of exploring our 843-acre park.

When voices rebound from the tunnel's mammoth walls, the Glen Span Arch embodies our interaction with nature—when humans revere and intervene in a world of vines. Through a tunnel, you see where we and nature intersect, and where the blueprints went right.

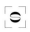

View From the Pool
Central Park
18' × 23.5' / 2006

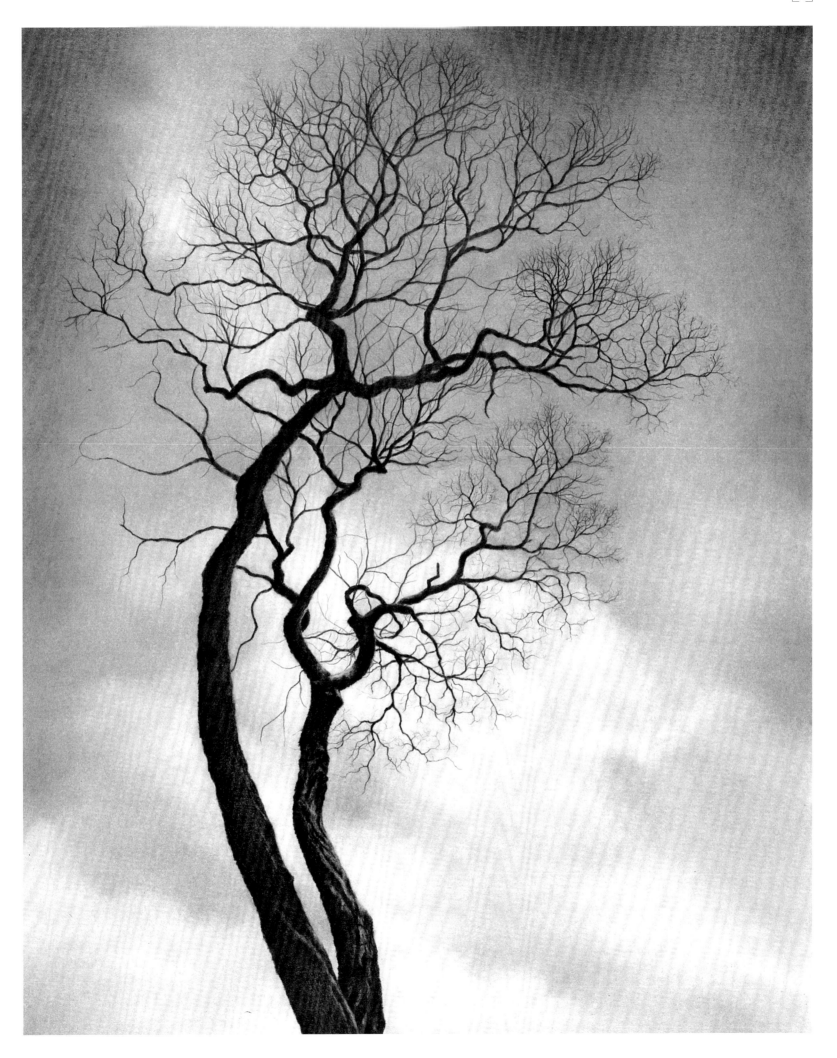

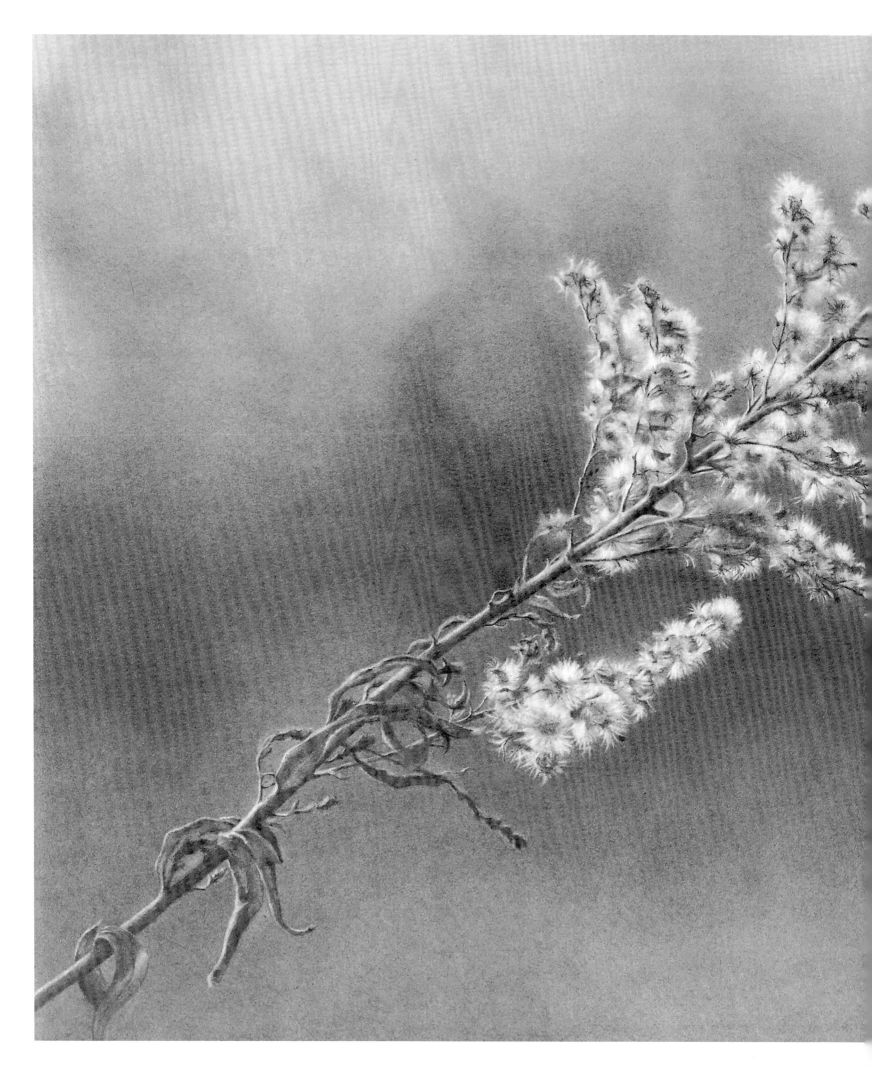

Taller Than Trees

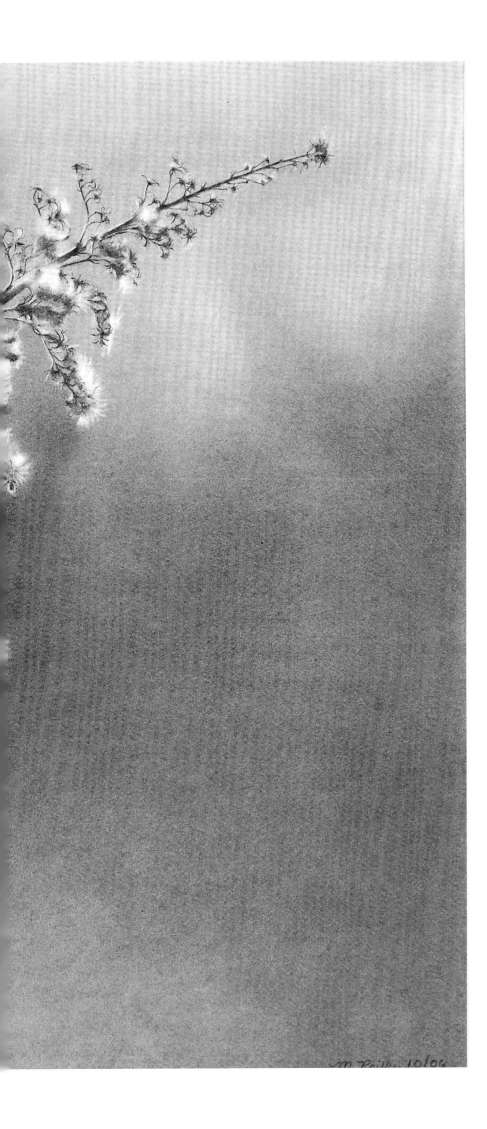

Following Page:
Fog in Central Park
Photographed by Luc Kordas

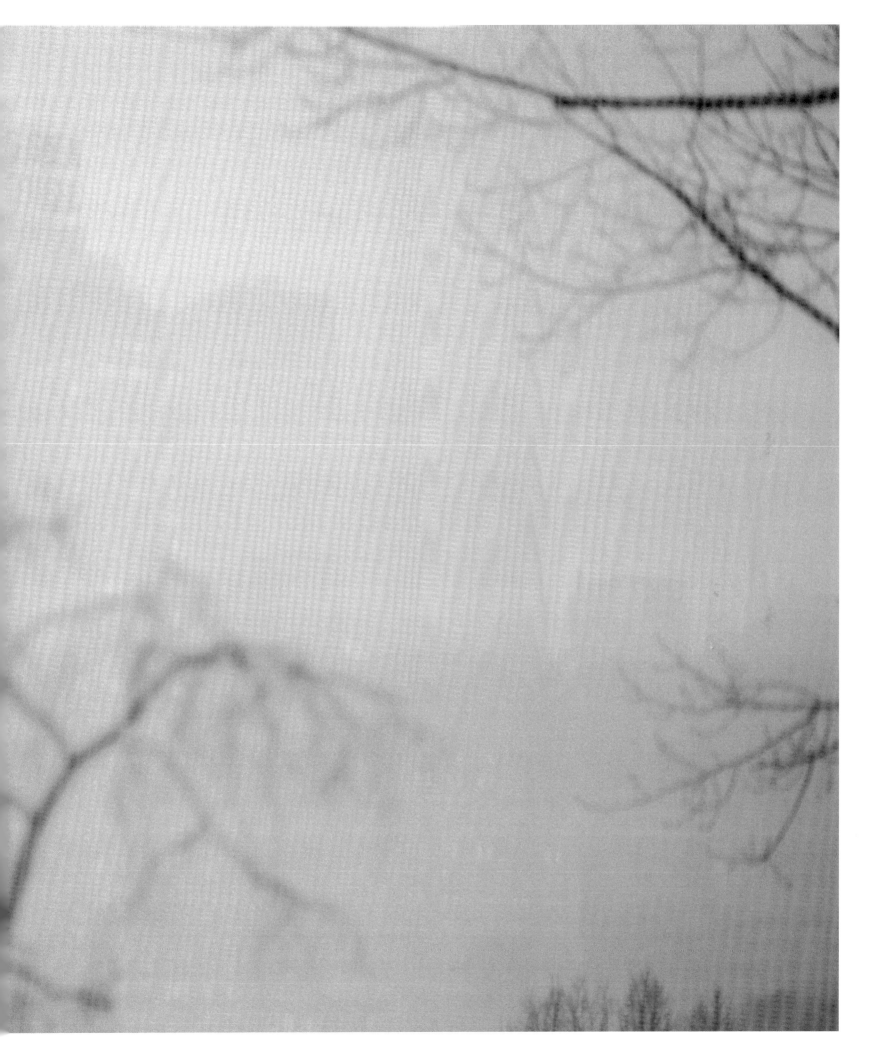

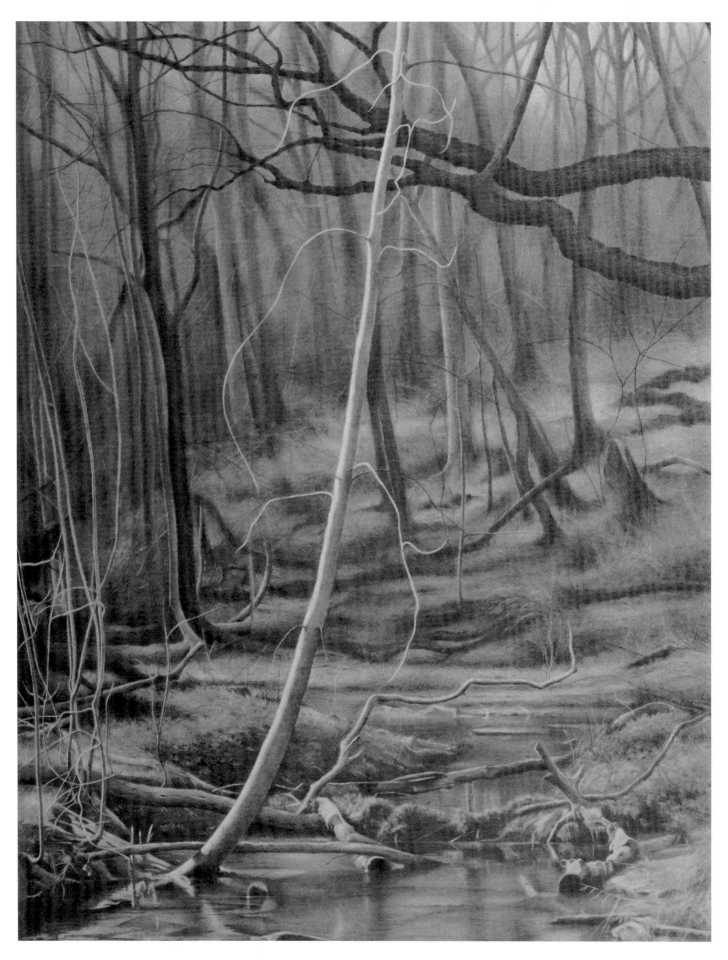

North Woods 1
Central Park
50" x 33.5" , 2006

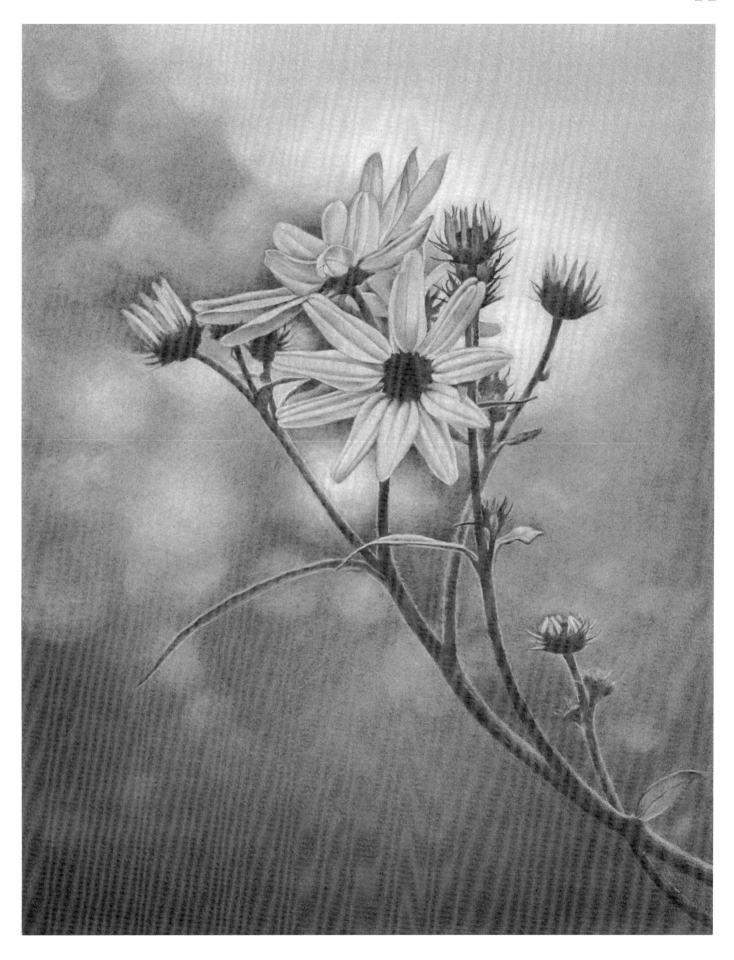

Wildflower
Central Park
18" x 13.4 / 2006

Moonlight

Imagine: in this classic Fifth Avenue scene, looking westward on 96th Street, the moon peeks through the trees and signifies a day's end. With relief, and thoughts of dinner, commuters put on their gloves to begin their routine home. First, they stand still like the ruling winter, exiting the office, letting white breath fill the air, and then finally stepping forward and homeward.

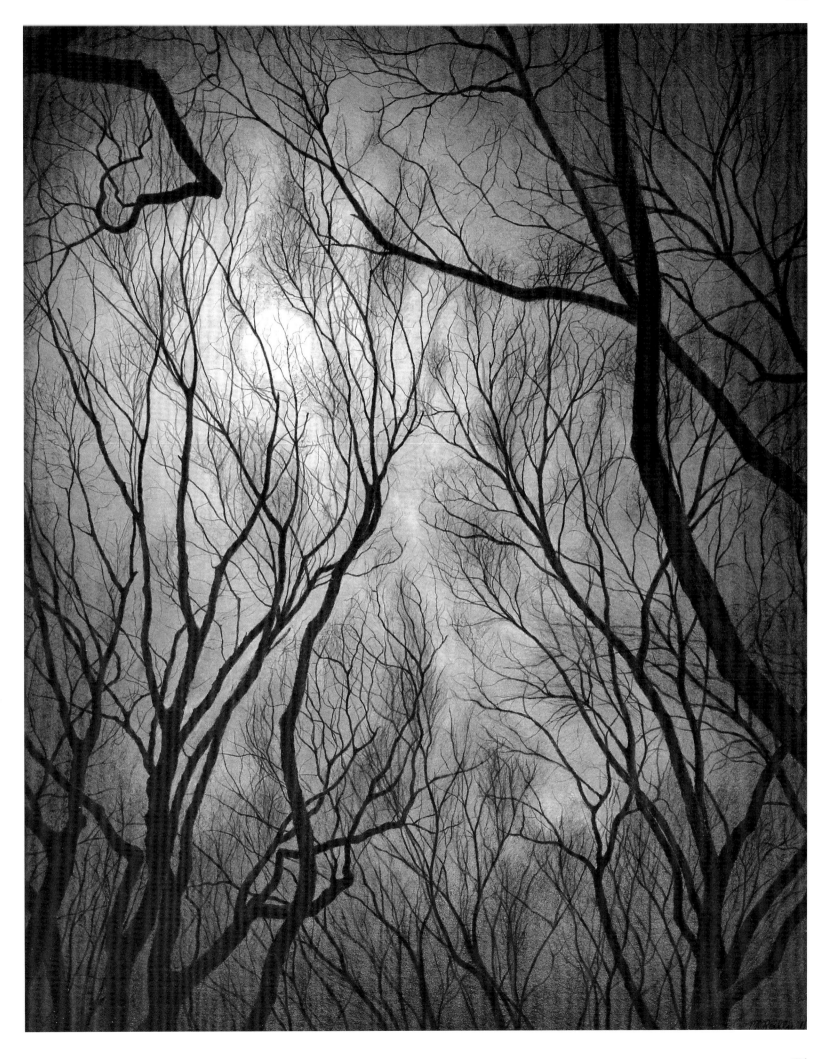

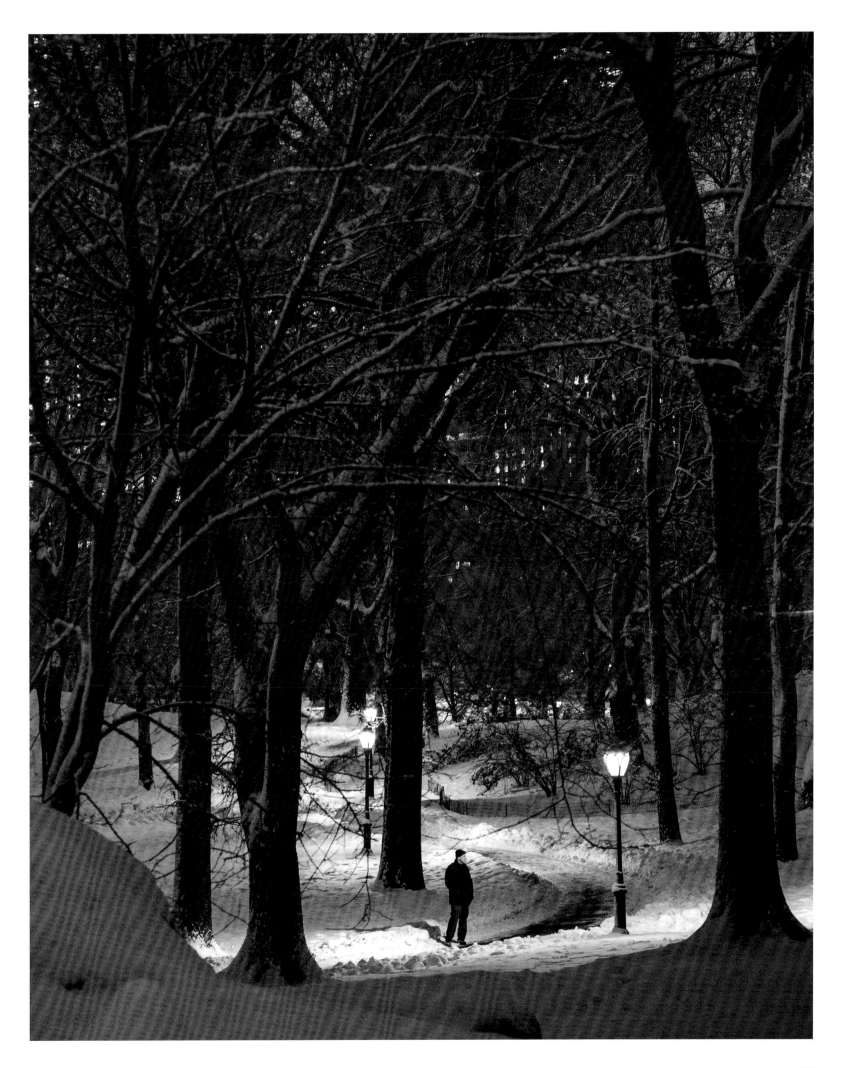

Fort Tryon Park

Fort Tryon was a gift to the city in 1931, with eight miles of running paths and a large, unrestricted garden.

Its inner floral paradise, the Heather Garden, breathes pleasure like Rococo art. The perfumed air lingers day and night, while meters away, the Cloisters, an extension of the Metropolitan Museum of Art, conjures the Romanesque-Gothic periods with immense medeival works.

While John D. Rockefeller, Jr. commissioned this public park on his private land tens of decades ago, the resulting neighborhood suffuses a decadent world history with rare New York complexion, begging daydreamers and scholars to explore.

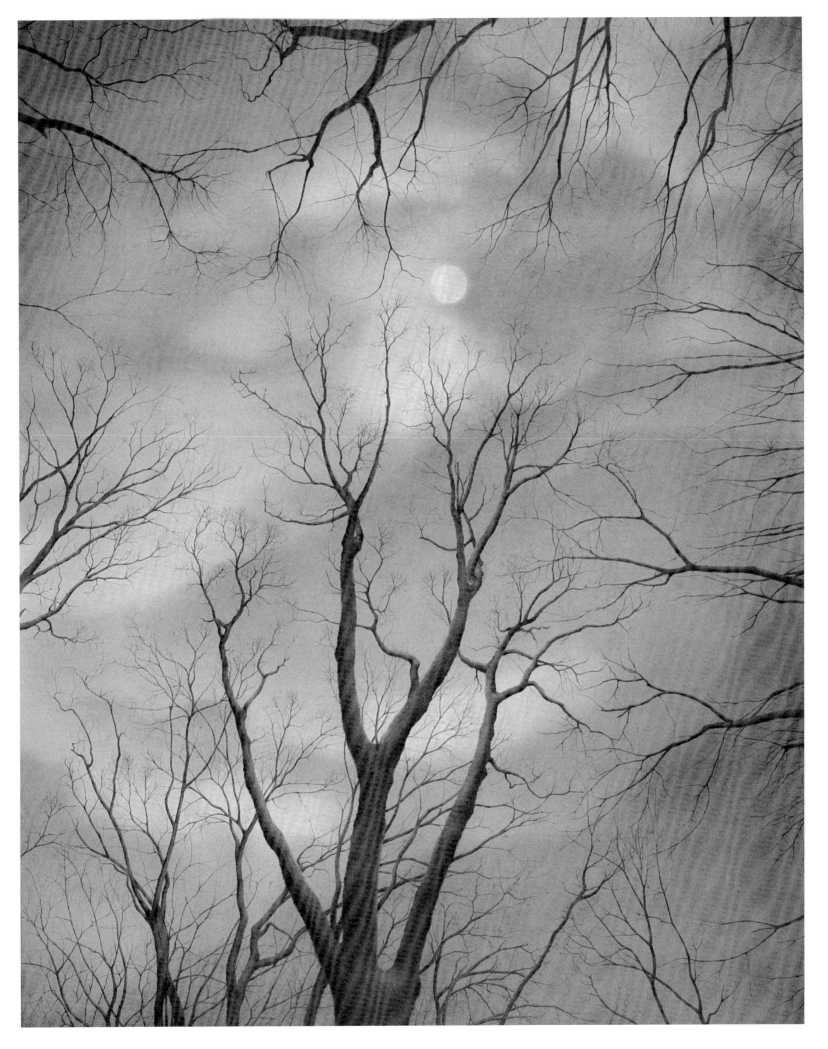

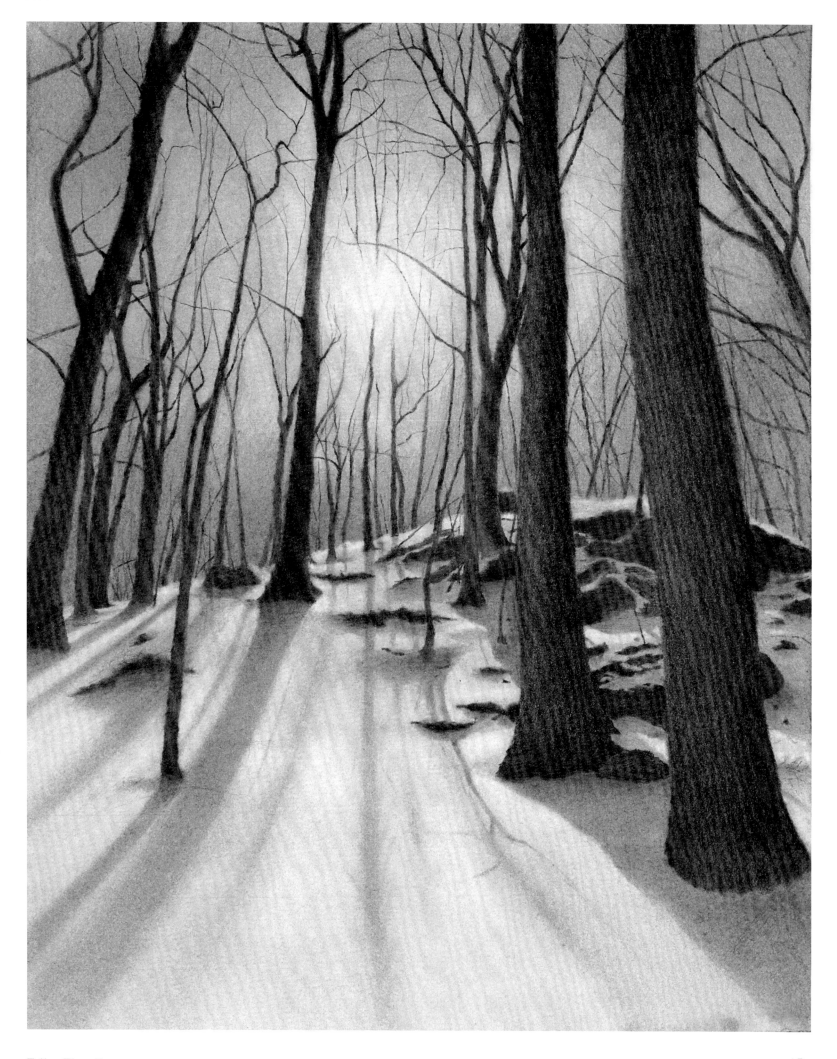

Low Sun, Inwood Hill Park

In Inwood Hill Park, meander like the caves. Don't look for anything in particular, but feel the trees hang high above, as if perceiving your place in their woods.

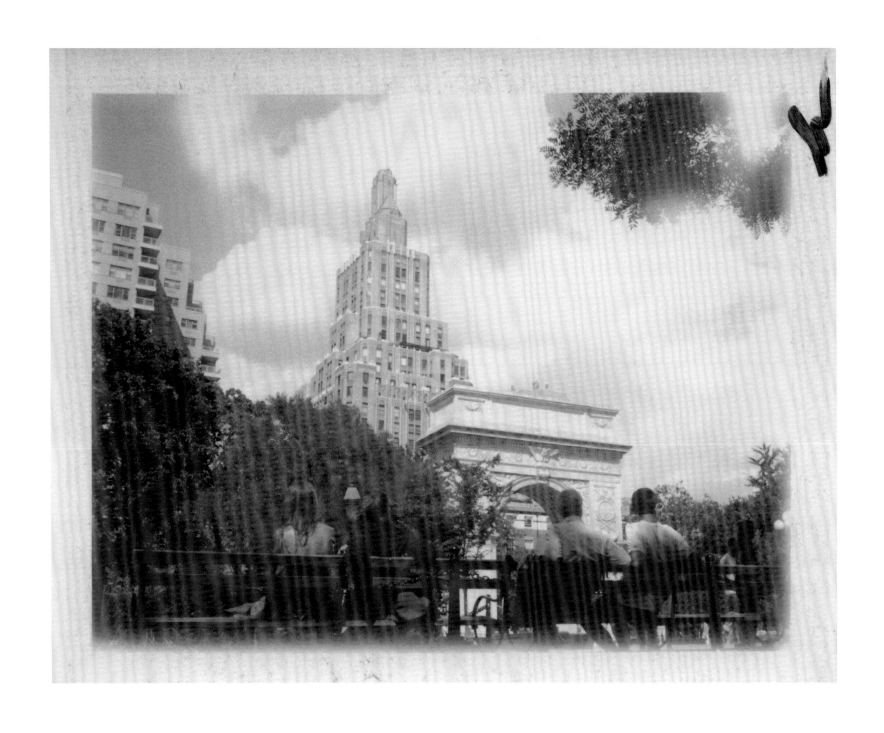

Washington Square Park
Photographed by Jean-Andre
Antoine

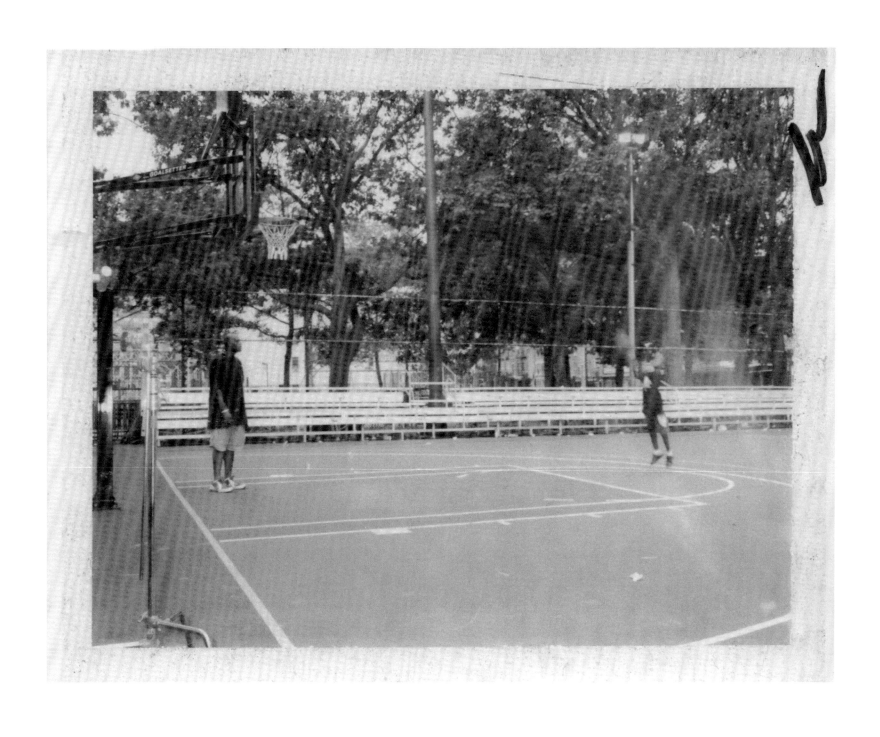

West 4th Street Basketball
Photographed by Jean-Andre
Antoine

Following Page:
Winter in Central Park
Photographed by Luc Kordas

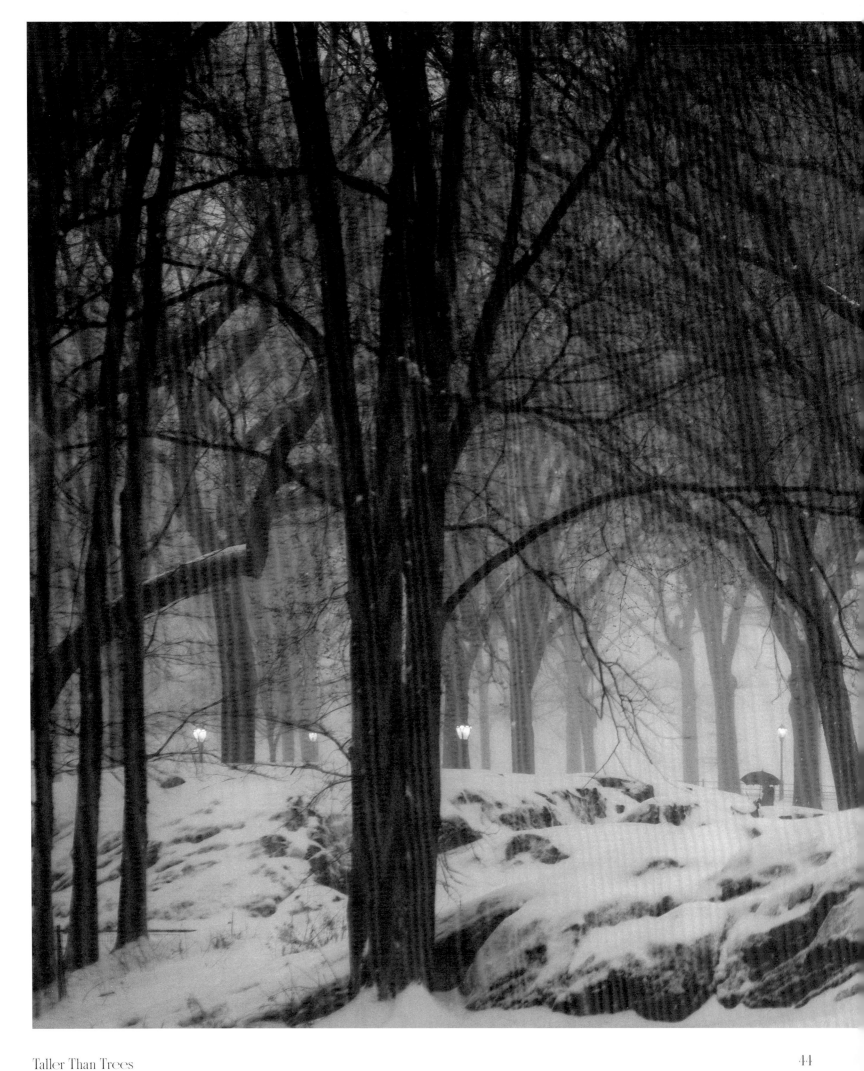

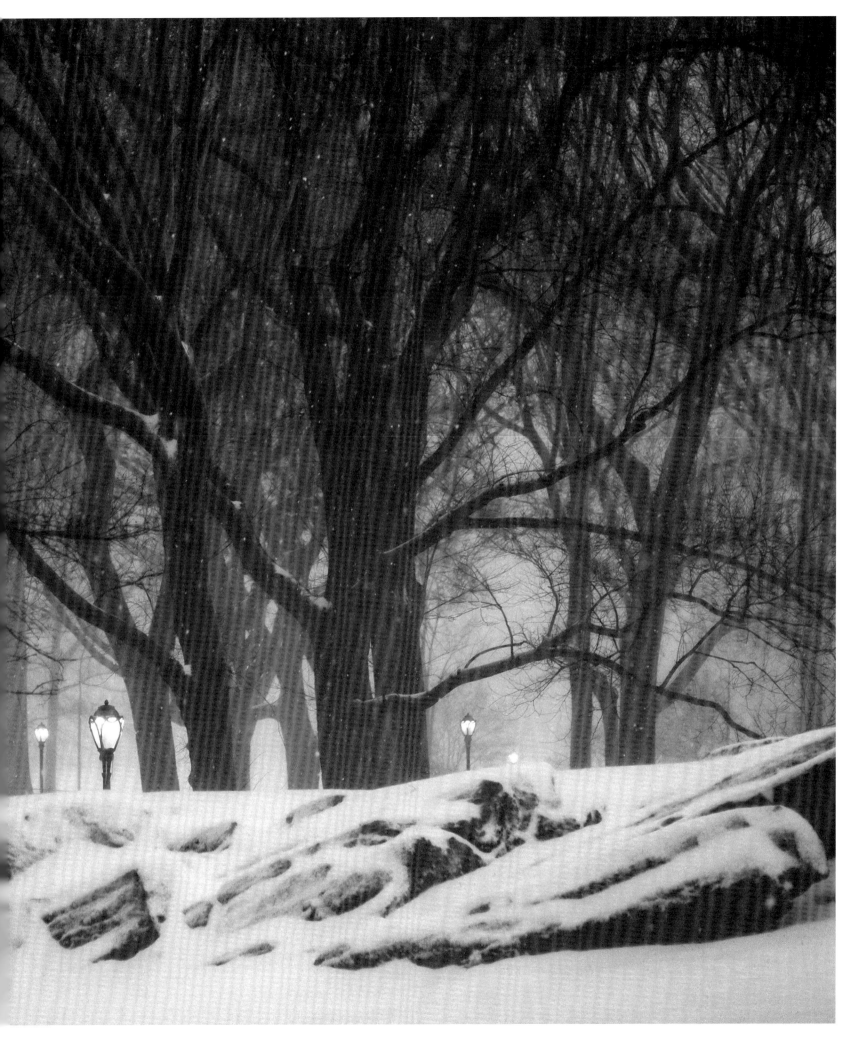

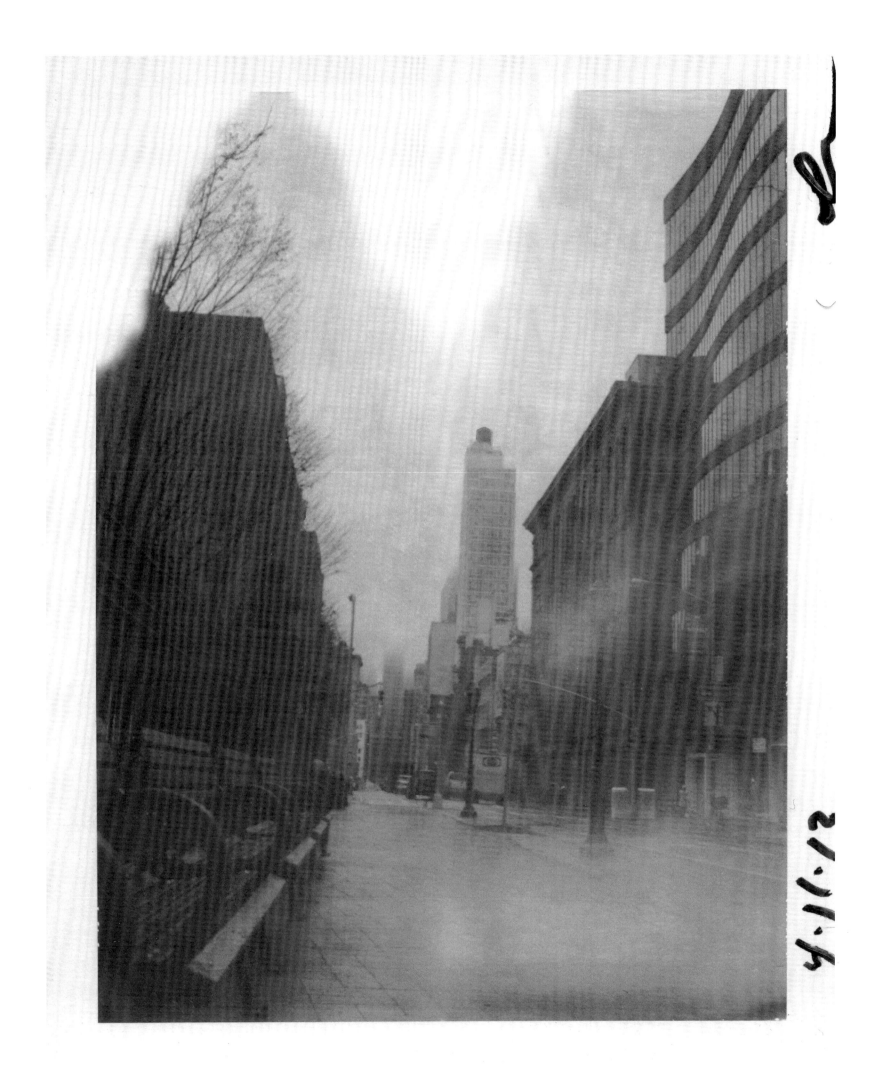

Queens

Chapter / 02

The local ice cream store has napkins now. *Use your sleeve,* they used to say to customers whose sticky hands followed them through a sunny day in Corona Park. But even with the napkins, those ices still taste like home. Queens tastes like home. It's home to everyone's parents, who lingered when their kids moved to the city. It's home to those who stayed. It's home to some of New York's most beautiful parks, whose tall trees are an artist's playground, or just a wanderer's hideaway. Queens is in time and above it, memorializing its history and future at once in its graffiti, its trees, its sidewalks, its red bricks, and its very being.

Dunes 2
Breezy Point Tip
18" × 23.5" / 2004

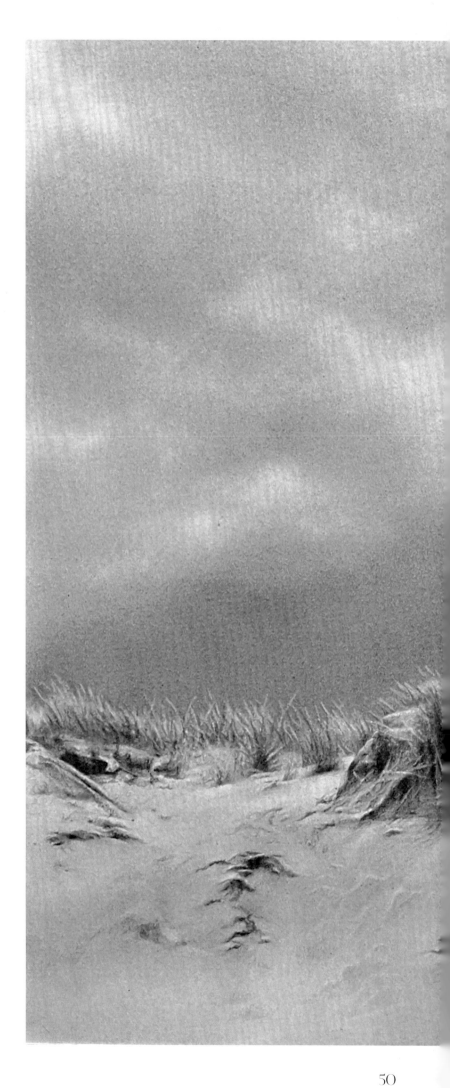

Taller Than Trees

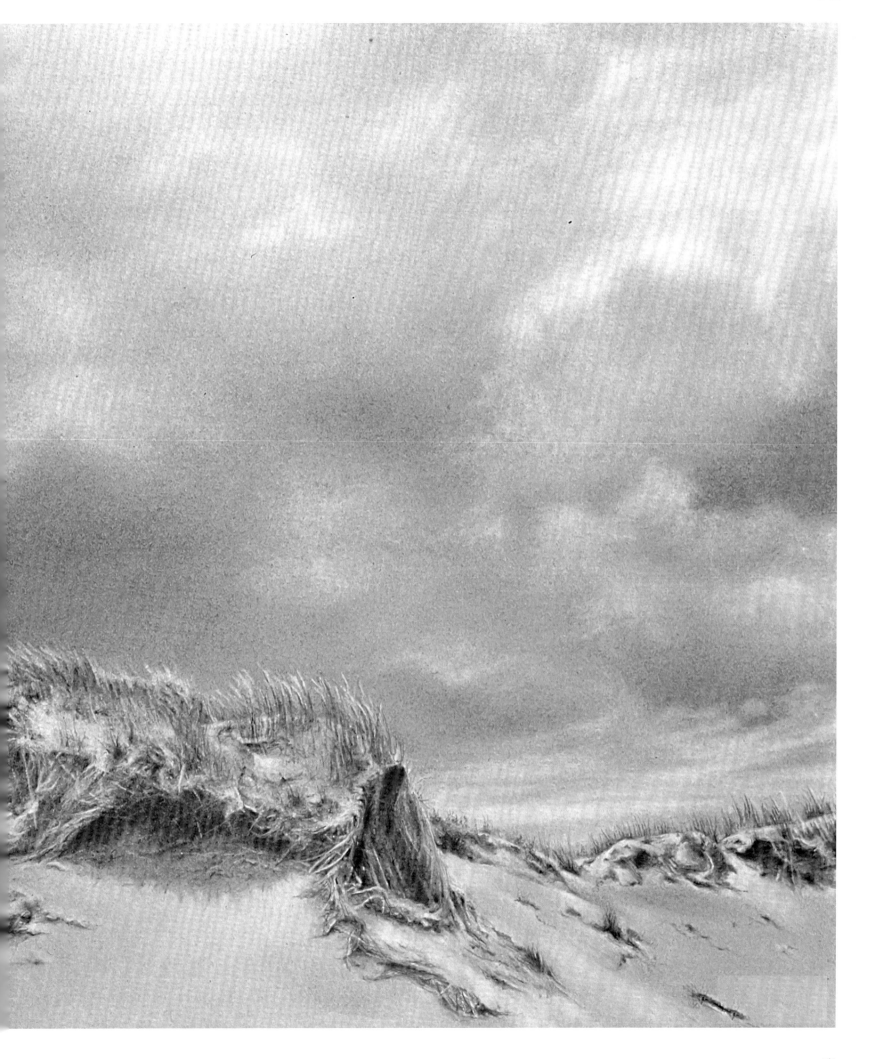

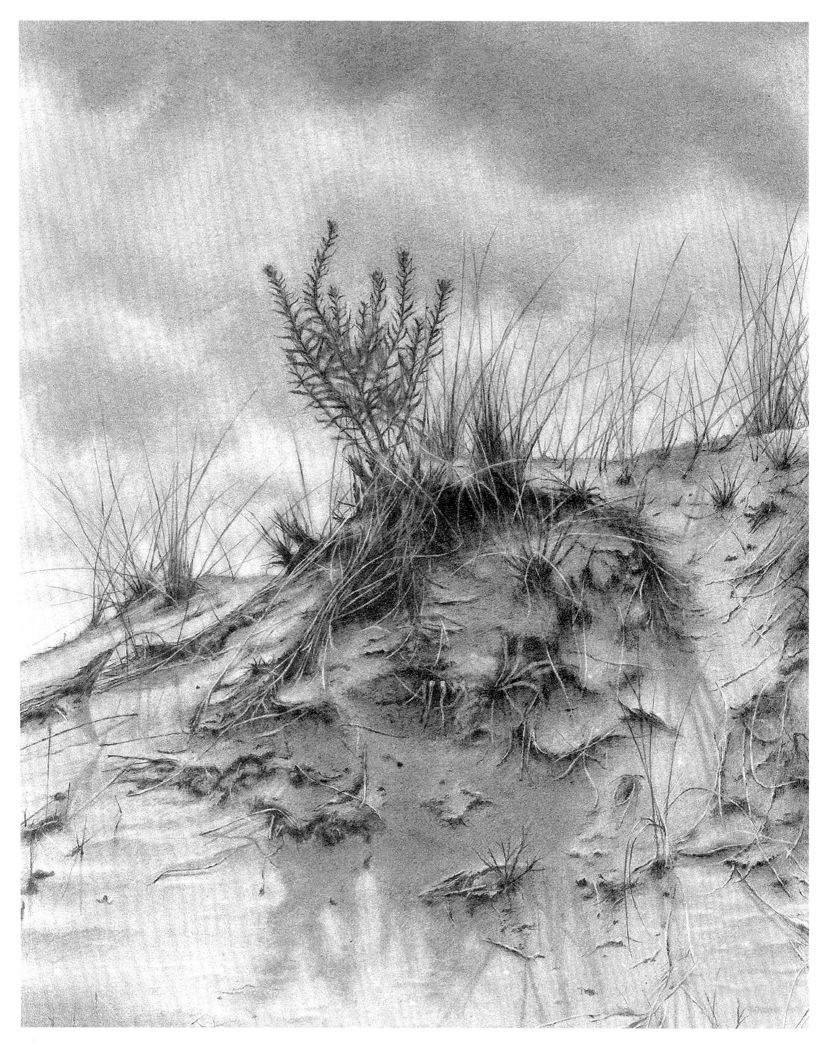

Breezy Point

You taste the salt in the wind, sitting at the tip of Breezy Point, imagining yourself living in a balmy beachside bungalow once the summer arrives. It's the first day of spring, marked by the gentle breeze and sudden desire to read a book. The streets and beaches are mostly empty, no beach chairs out yet. The dear equinox pulled the world upward, brought it high, despite the scattered bare sticks and other remains of winter. The sand pools into your sneakers, but that is a problem for later.

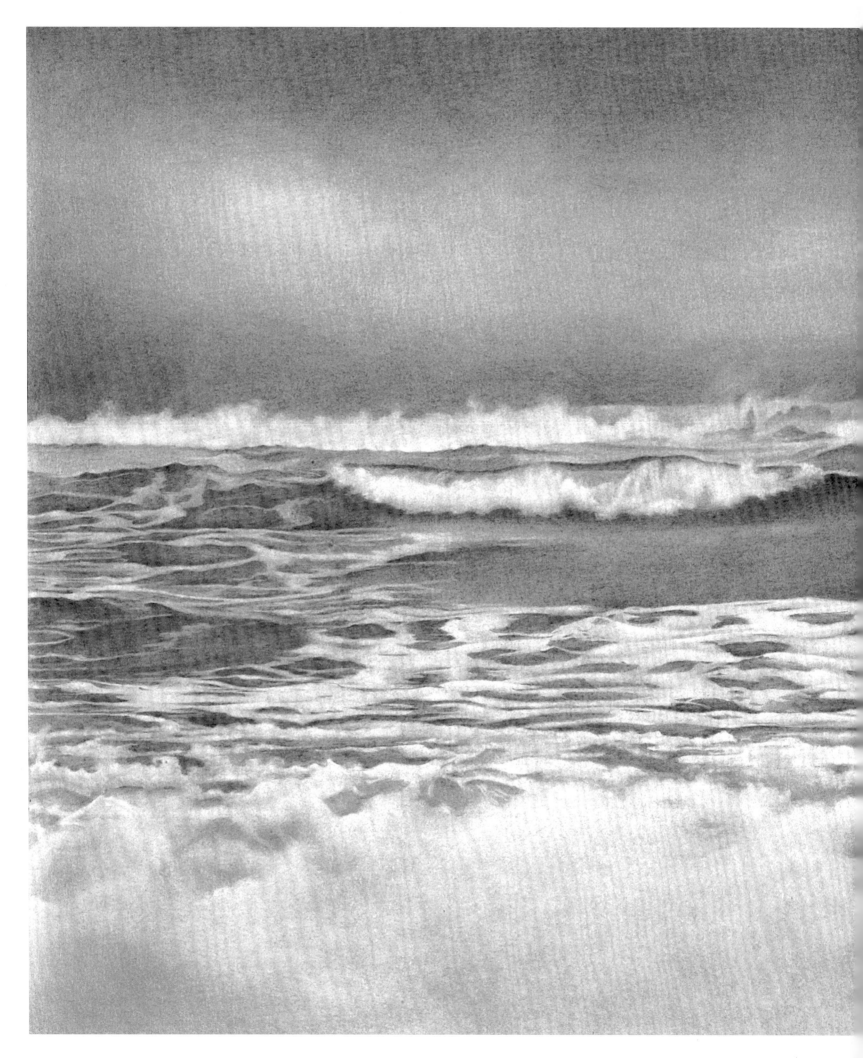

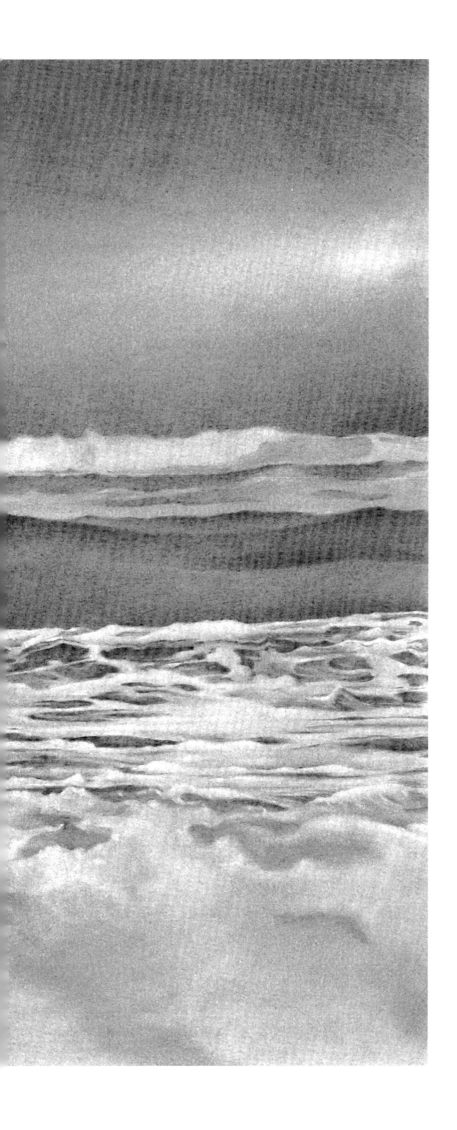

Breezy Point 3
Breezy Point Tip
Collection of New-York
Historical Society
38" × 50" / 2011

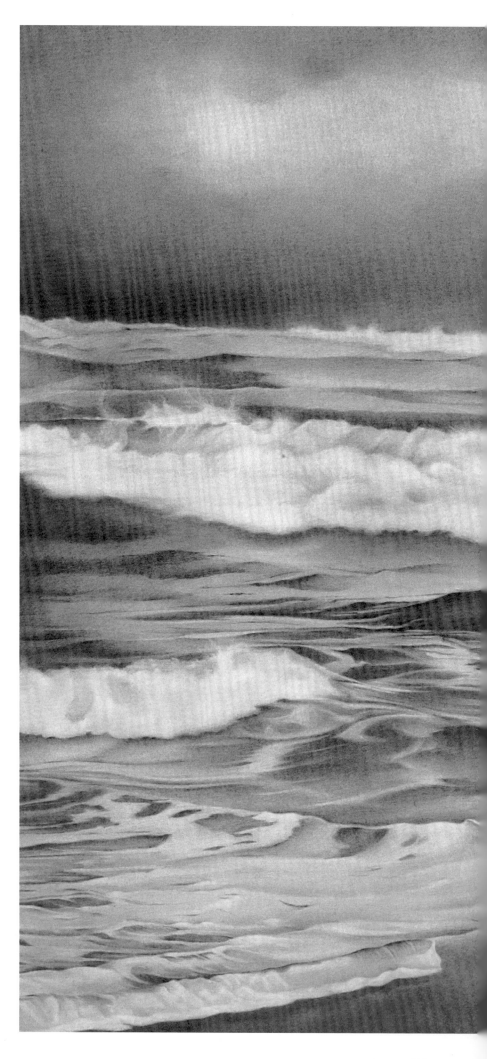

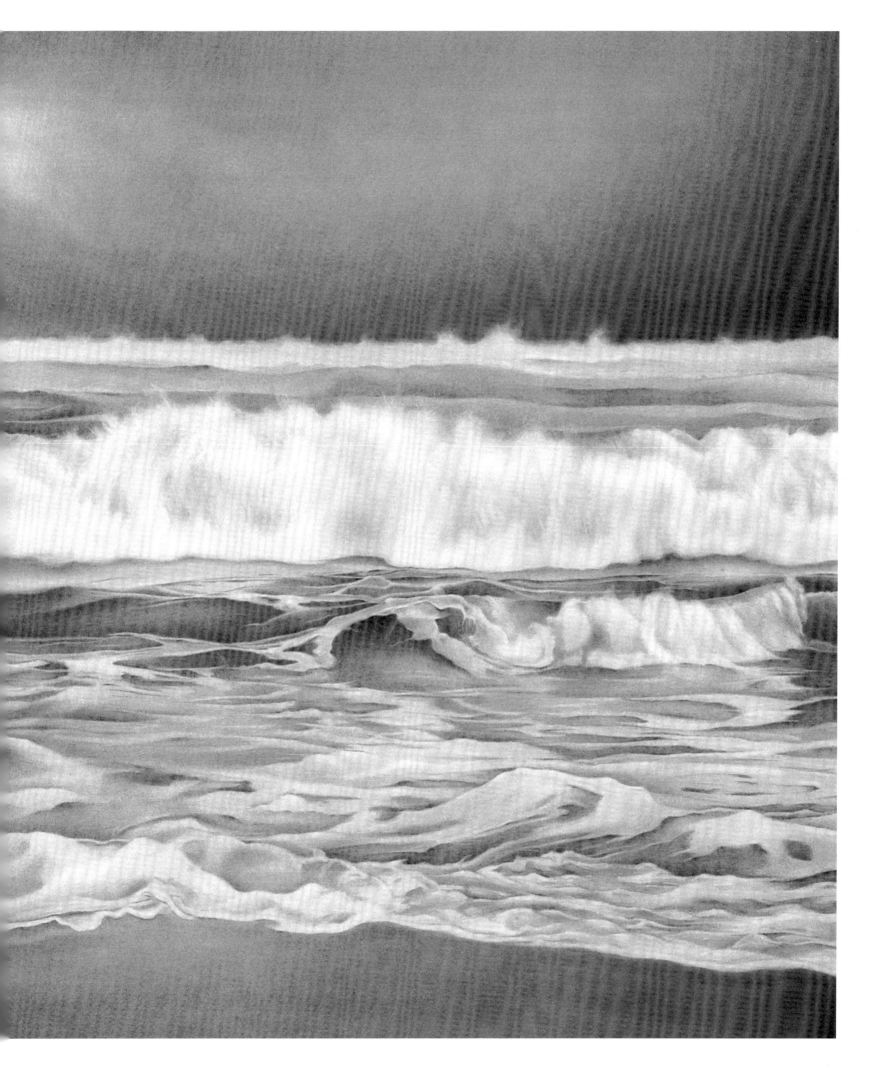

Wildflower, Jamaica Bay Wildlife Refuge

The Wildlife Refuge, a swampland adjacent to Howard Beach and its many cool summer cottages, is a picture of local New York lush.

Located in Broad Channel, the southern slice of the borough, these marshes provide sanctuary to wild birds and other native critters. Indeed, with hard work and blooming sustainability, pollution was cast away and the snowy egret and flossy ibis returned.

A city-dweller can visit and rove the expanse of Jamaica Bay, on warm days, long days, loud days, and days that require a certain pause. While feathered bodies fly high and migrate far, the wildflowers' pollen travels too, dust in the air, unseen on its vitalizing journey.

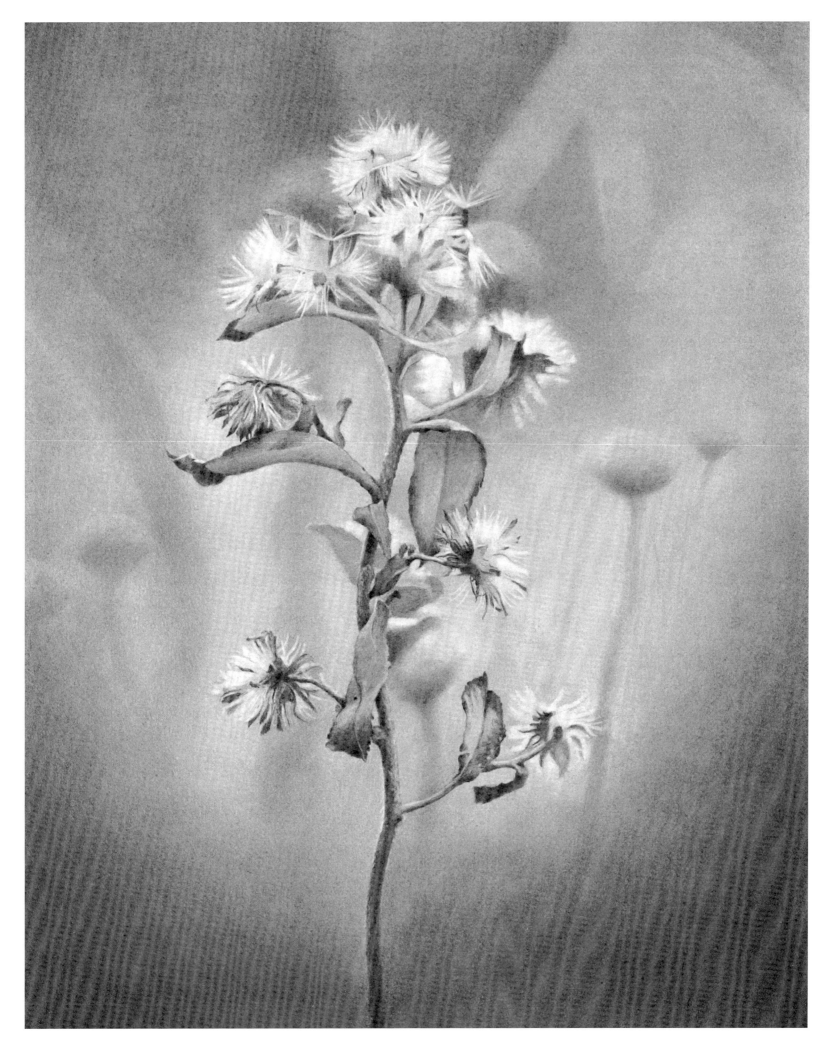

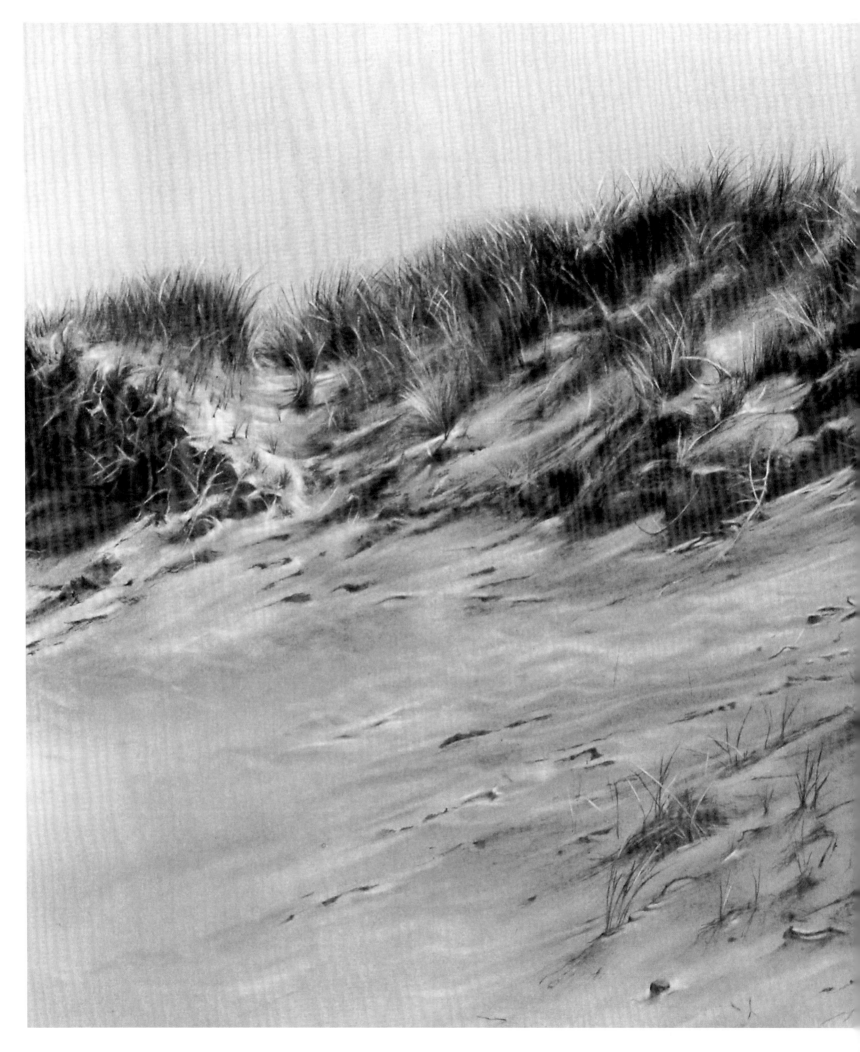

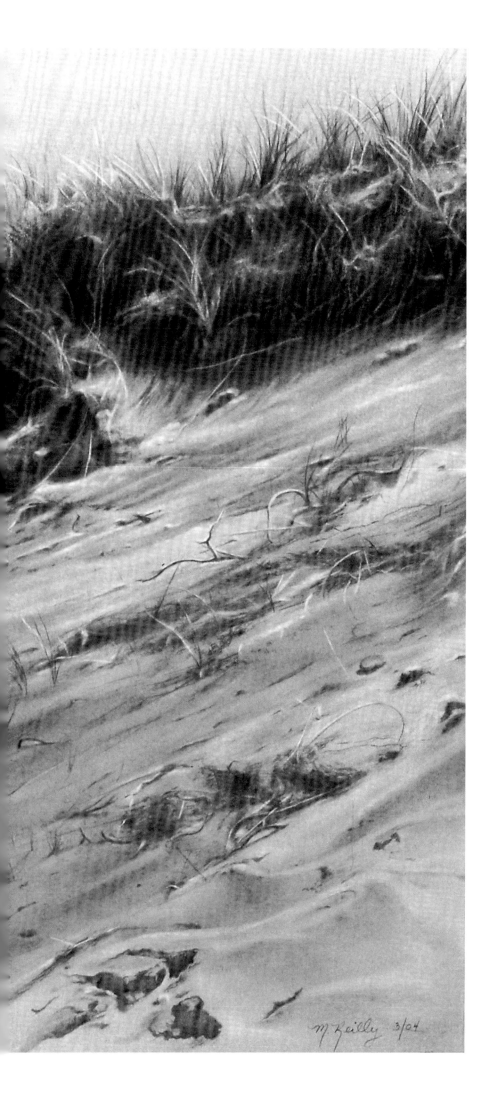

M. Reilly 3/04

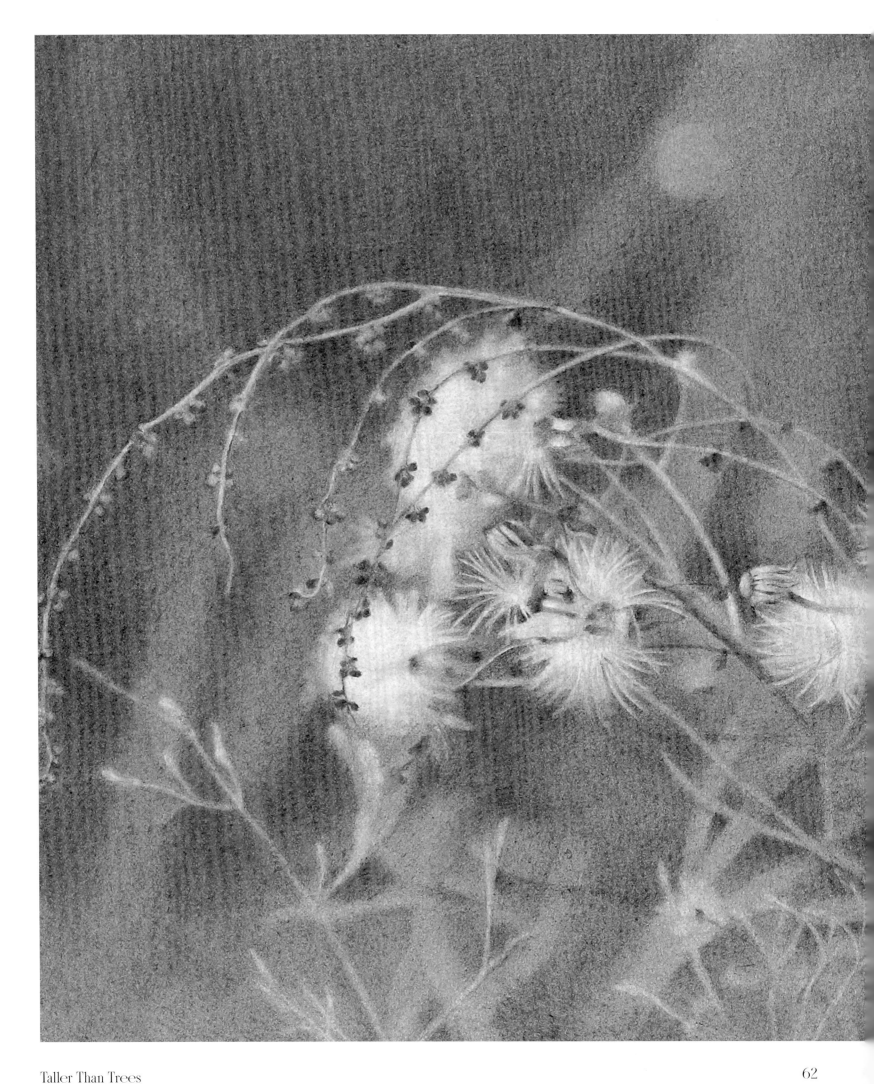

When I first saw Mary Reilly's extraordinary graphite drawings about 10 years ago, the depth and detail of her work stopped me in my tracks. As a passionate lover of drawings, I found the extraordinary range of tones, shades, and gradations she achieved with this widely-used, common medium to be utterly captivating. Even more poignant was the meditative spirit they instilled in me. I still think of them as whispers in graphite.

Mary's drawings are a celebration of nature. The solitary views she shares with us of intimate moments in the forest, field, beach, or park offer a respite from the busy, oversaturated world we have come to inhabit. All of her works fill the entire sheet of paper, edge to edge, immersing us in a rich tapestry of imagery. They invite us to investigate the myriad details, offering a timeless space for us to pause and reflect on the natural world.

Her *Graffiti Trees* were my first love. This documentation and memorialization of hand-carved initials and messages on various old growth New York City tree trunks offer a romantic nostalgia for times past, and evoke dreamy memories of adolescence. The drawings are also a commentary on the perseverance of the living world. They are simply great fun to boot, and possess a relationship to street art that is part of our everyday culture in New York.

When studying Mary's work I am often reminded of the grisaille paintings of the Renaissance. Grisaille (French for "grayness") was a *trompe l'oeil* technique used by many artists to depict sculptural forms on a two dimensional surface. Trees, being inherently sculptural entities, command a profound sense of depth and form in Reilly's work. Her shading and use of blurred backgrounds push these arboreal statues into our space and capture light and shadow in a way that welcomes us to cohabit the scene.

I am grateful and honored to represent Mary's art and to share with the public her masterful drawings. I always look forward to seeing new magic from her studio.

— Elizabeth K. Garvey
Director, Garvey Simon Gallery

Graffiti Trees

Mary Reilly's *Graffiti Trees* trace the intimate yet anonymous stories of New York city dwellers as they tag and experience nature. To create this series, Mary traveled all five boroughs to illustrate the etchings created by the New York Everyman.

As one walks through a landscape, ponders their identity, their footsteps, and the place they'll one day arrive, they incarnate the experience Reilly had in New York City. By tracing lifetimes and love affairs written on the trees of neighborhood parks, we understand the profound importance of nature, even to urbanites who cherish their bustling environment. The universal impulse to carve a name or message on wood speaks to a yearning among us all to eternalize the present moment, and release the atomic feelings we have inside.

Our will to connect with nature, and tribute everyday memories by carving them into the earth, exists tenfold in a city where self-discovery abounds and meadows are contained by one larger grid. And so, the infinite imprints on New York City trees reflect a common intuition that nature is permanent, and where our identities fluctuate, we can rely on the outdoors as we try to rely on ourselves.

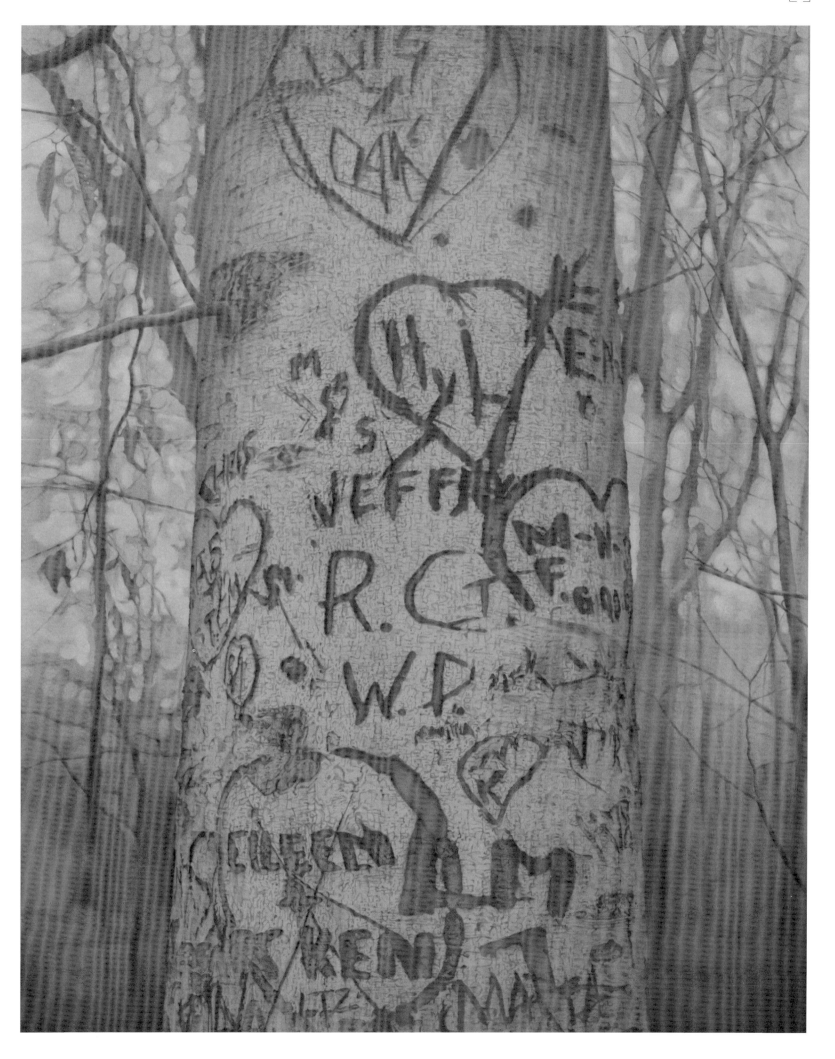

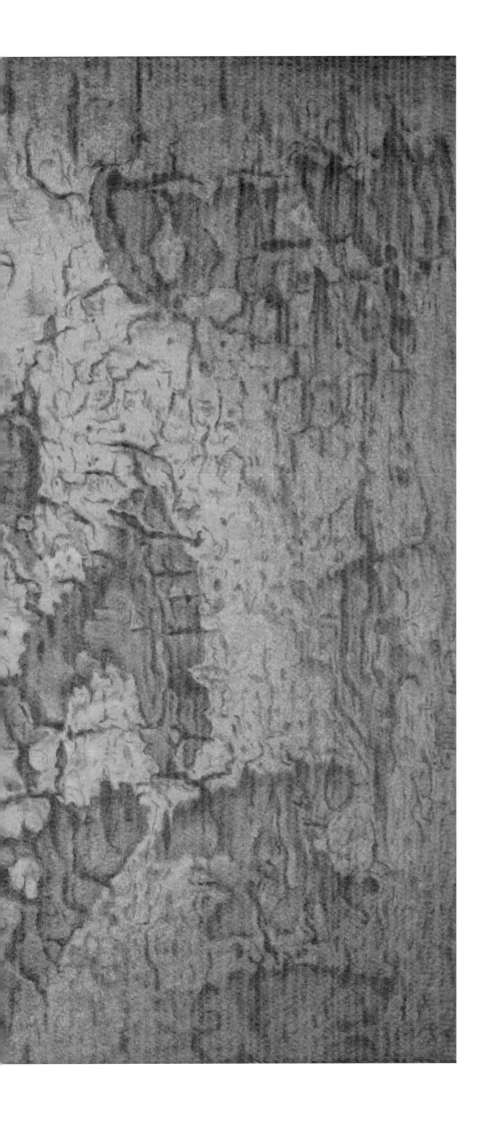

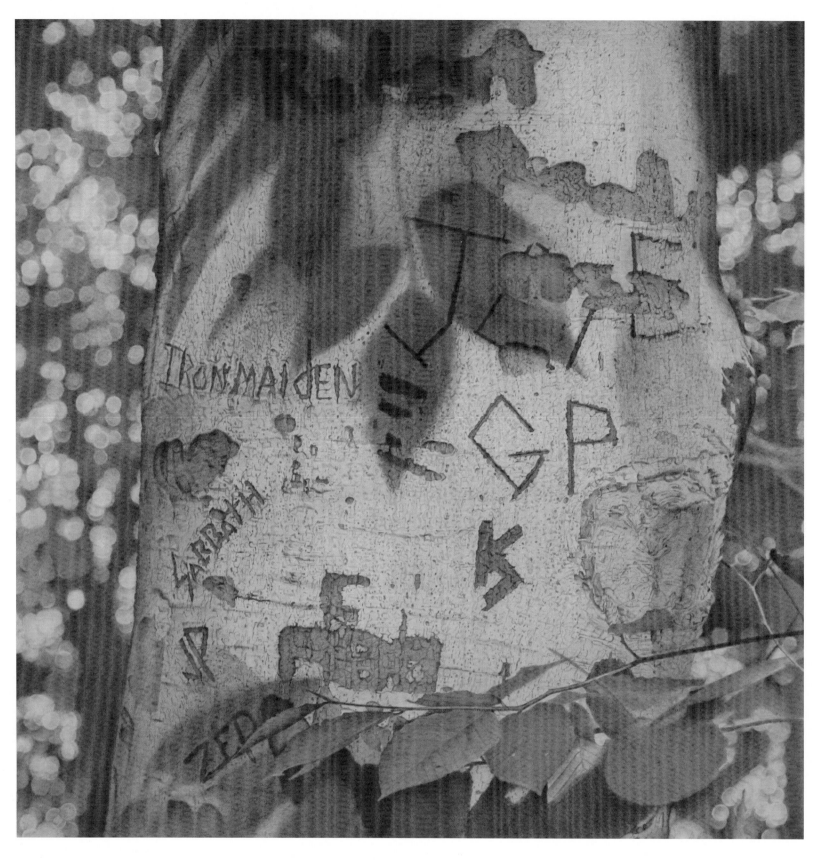

Graffiti Tree 4
Alley Pond Park
6' × 6' / 2013

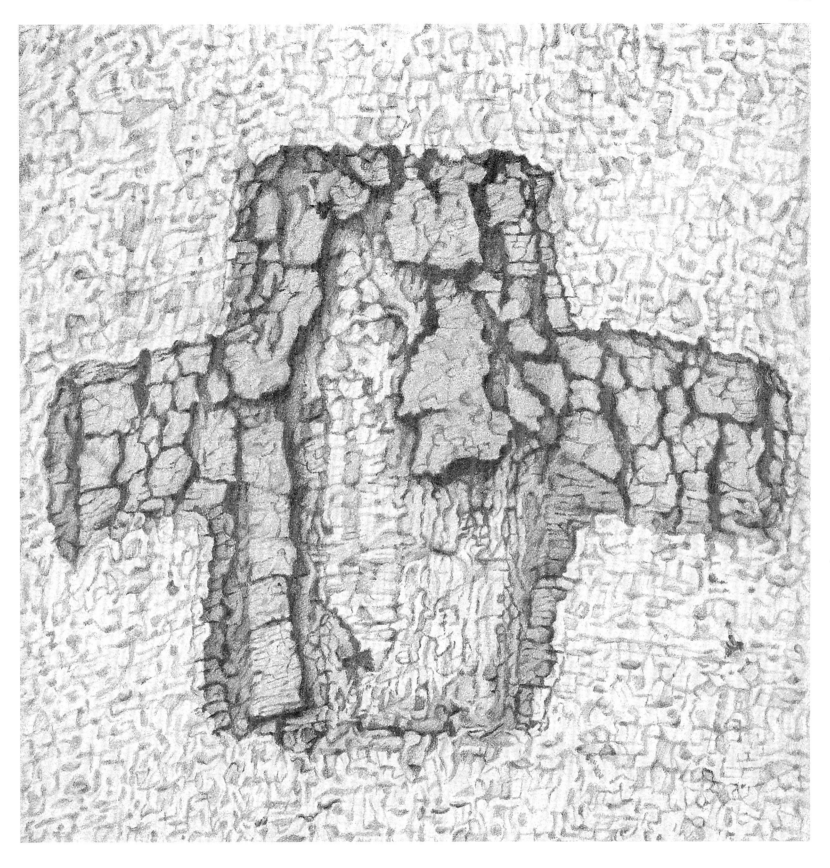

Holy Cross
Alley Pond Park
6" × 6" / 2013

Boy with Bowtie
Alley Pond Park
6' × 8.5' / 2014

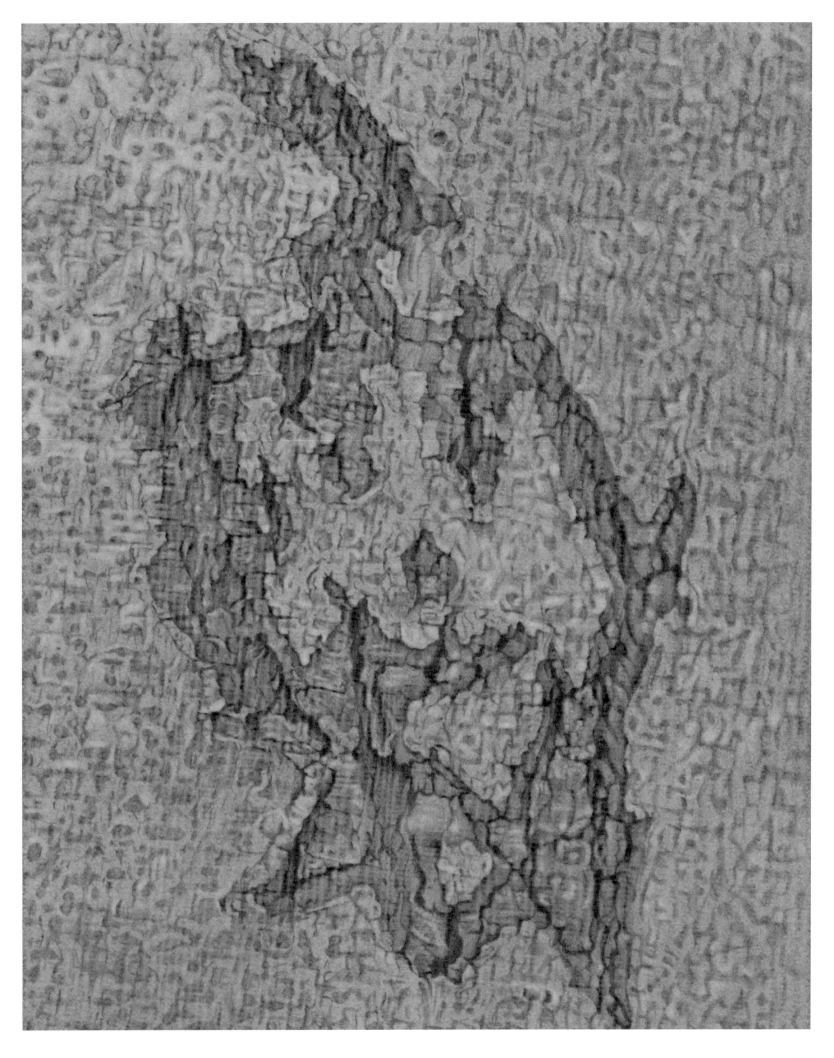

2000 Toke
Alley Pond Park
8.5' × 6' / 2014

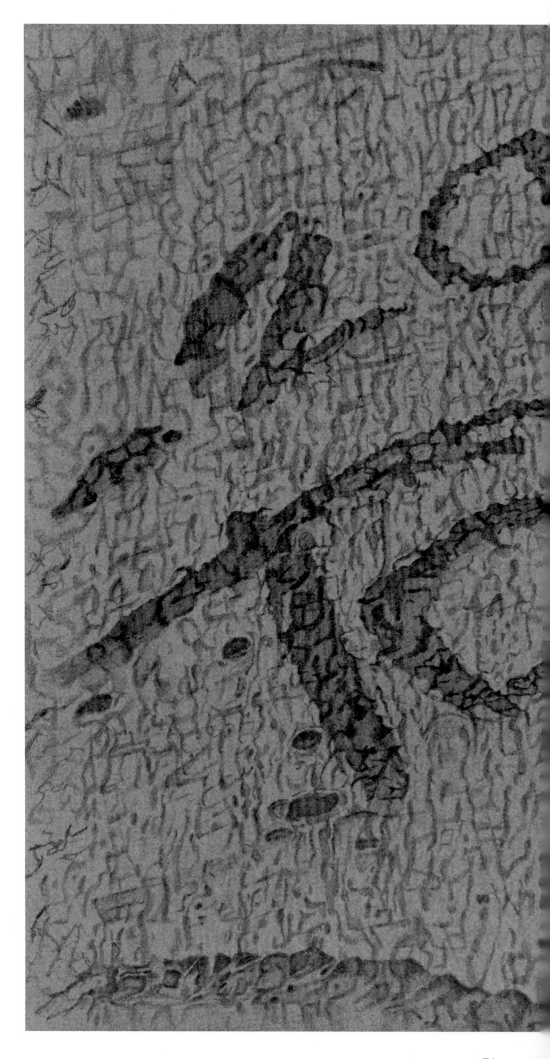

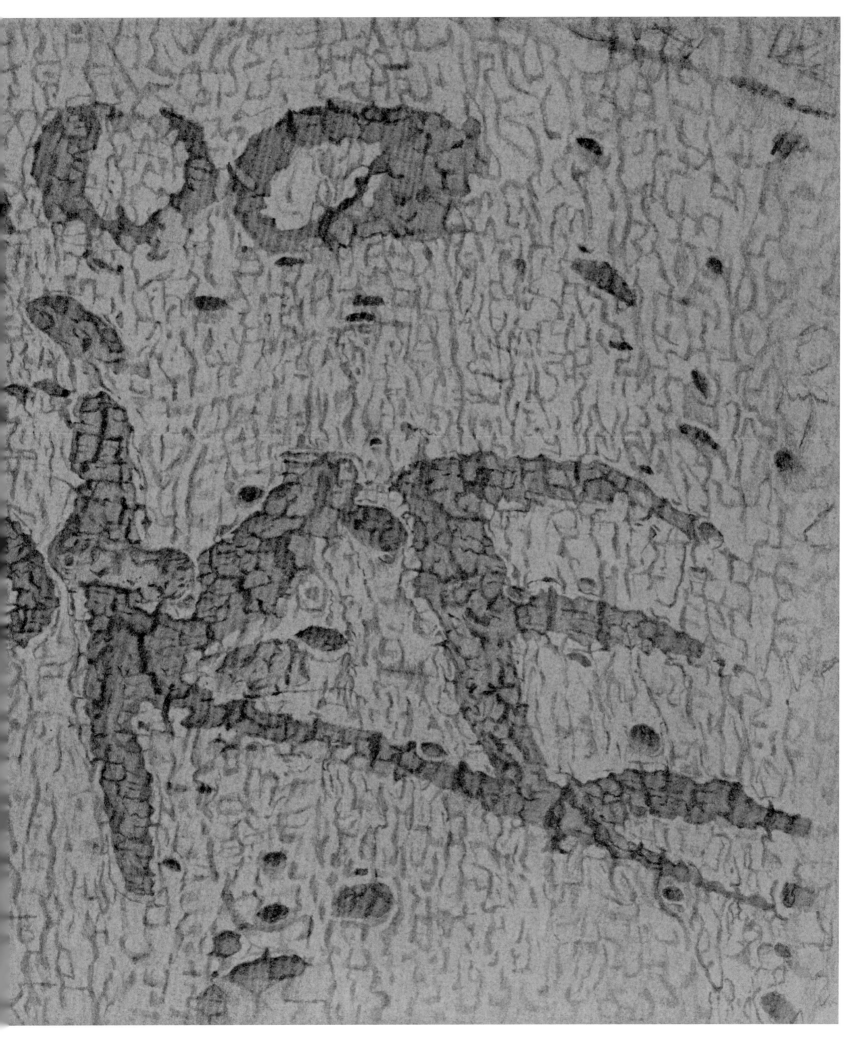

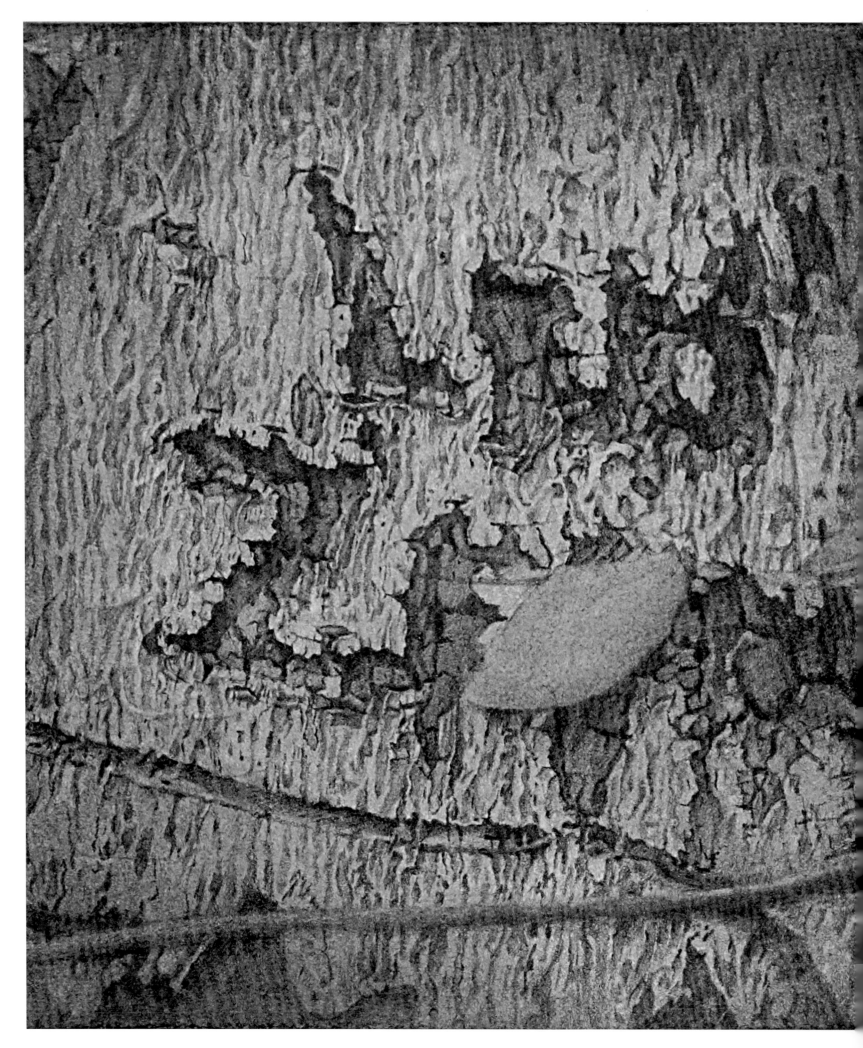

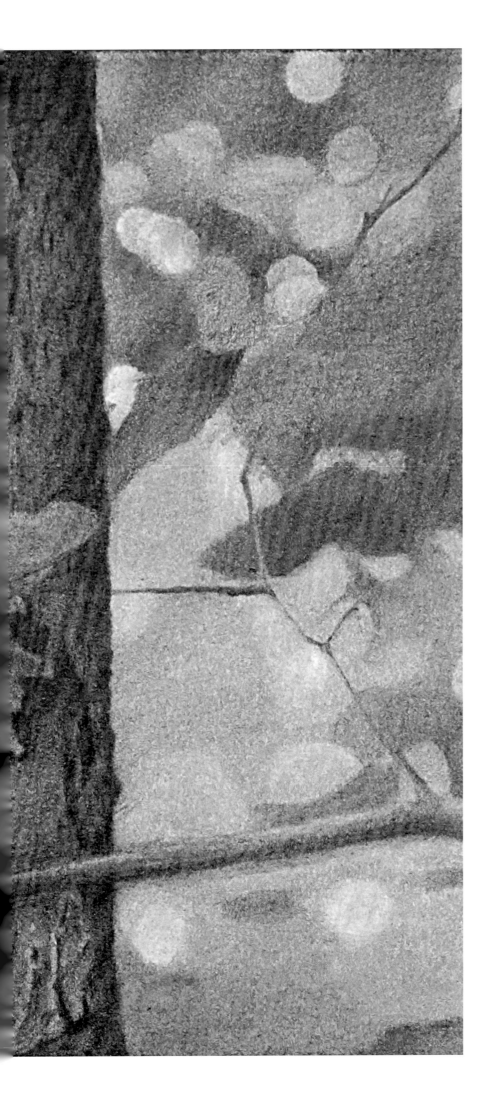

Led Zepplin
Alley Pond Park
6" x 8.5" / 2014

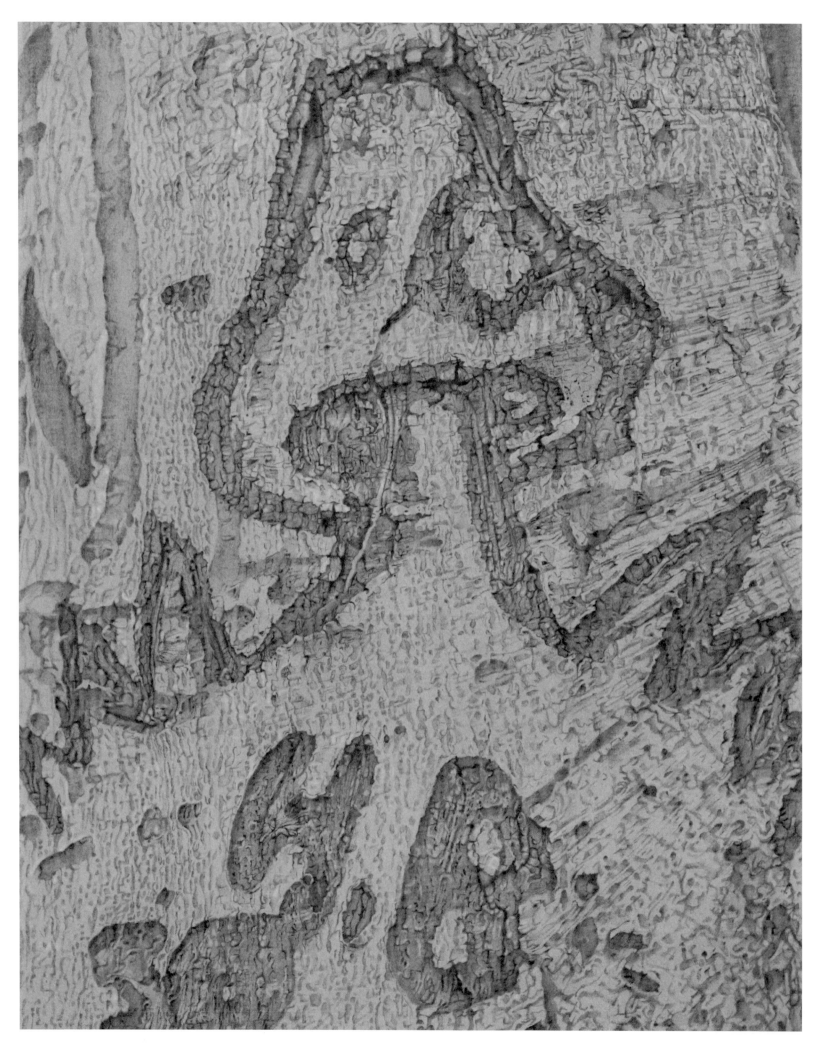

Mushroom Man
Alley Pond Park
16.25' × 8' / 2014

Jack Loves Kat
Alley Pond Park
10.75' × 13.5' / 2013

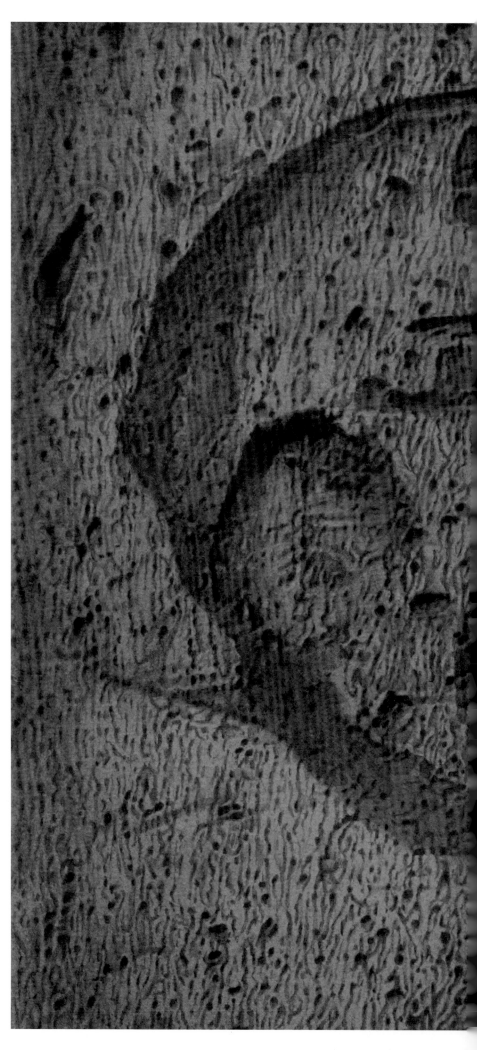

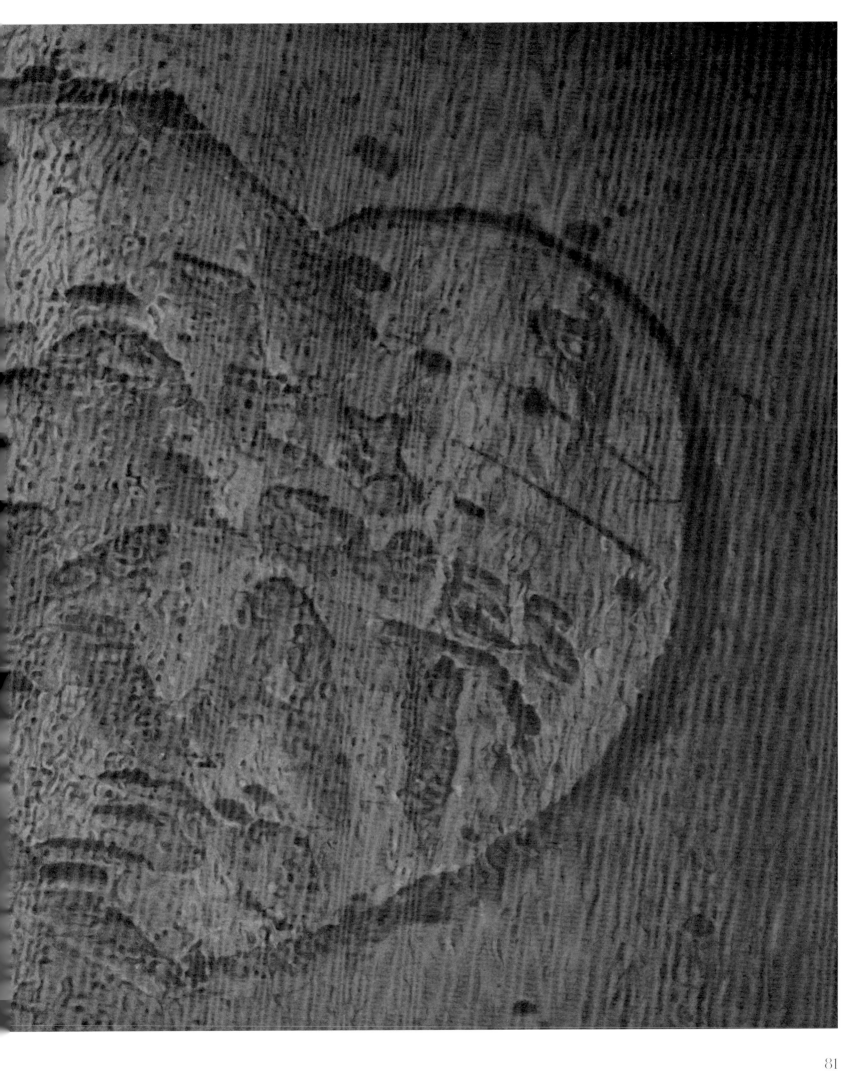

Luv Shines
Alley Pond Park
23.5' ×18' / 2014

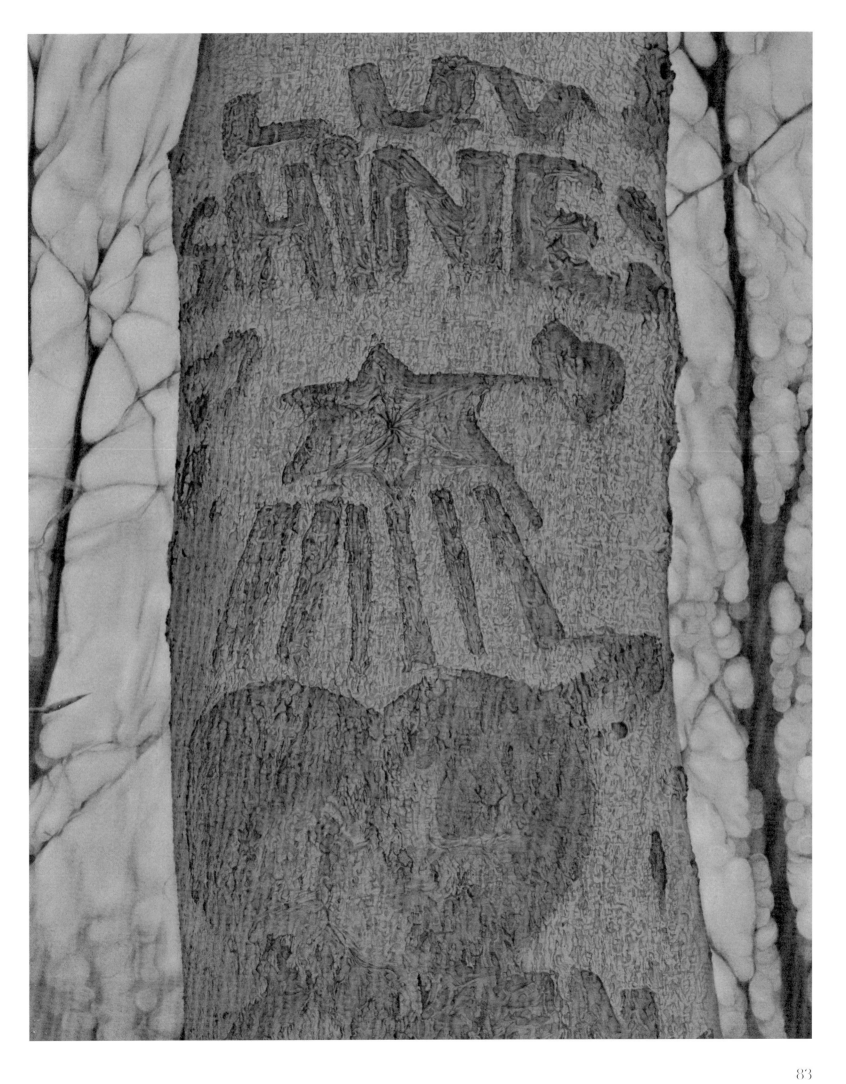

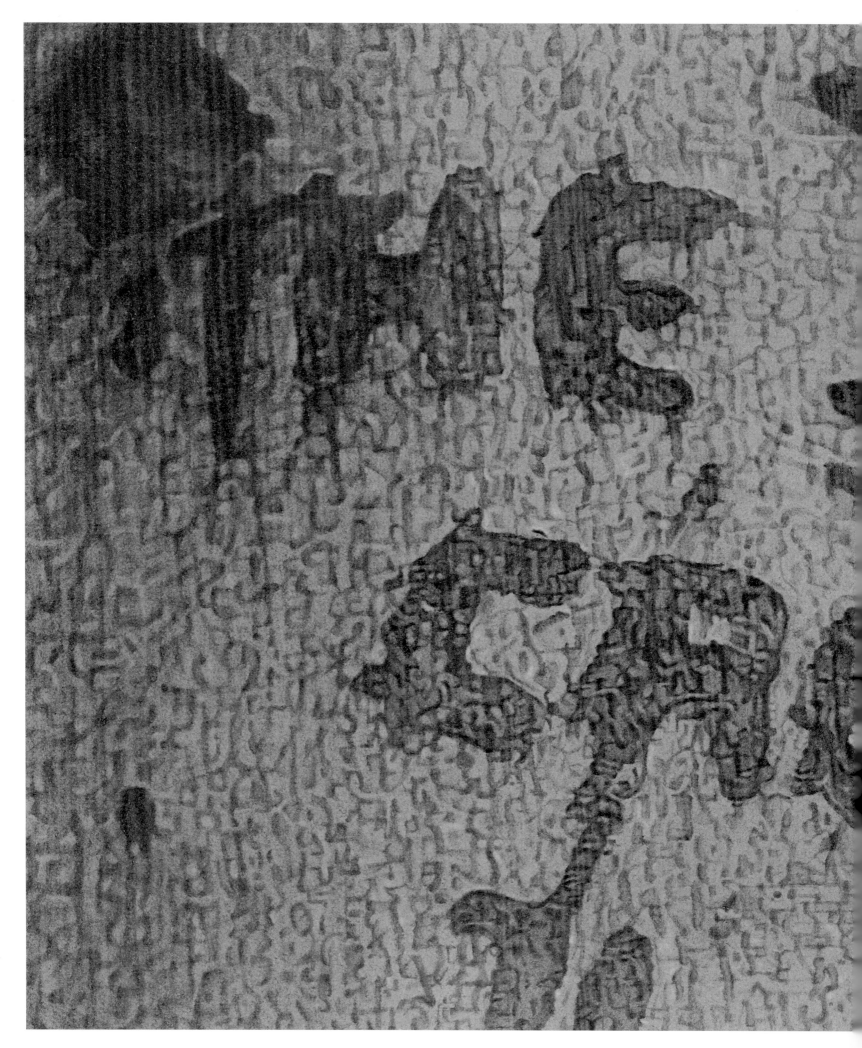

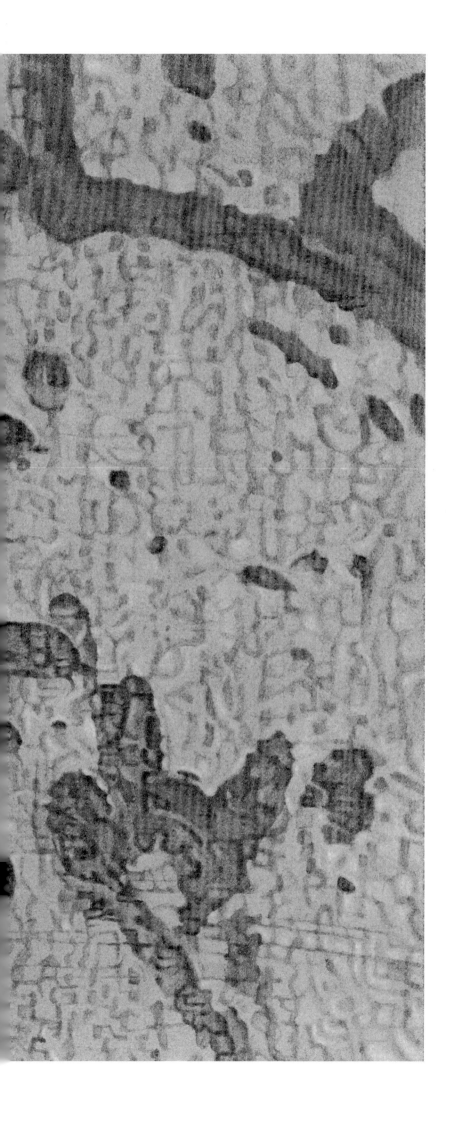

Peace
Alley Pond Park
6' × 85'/ 2014

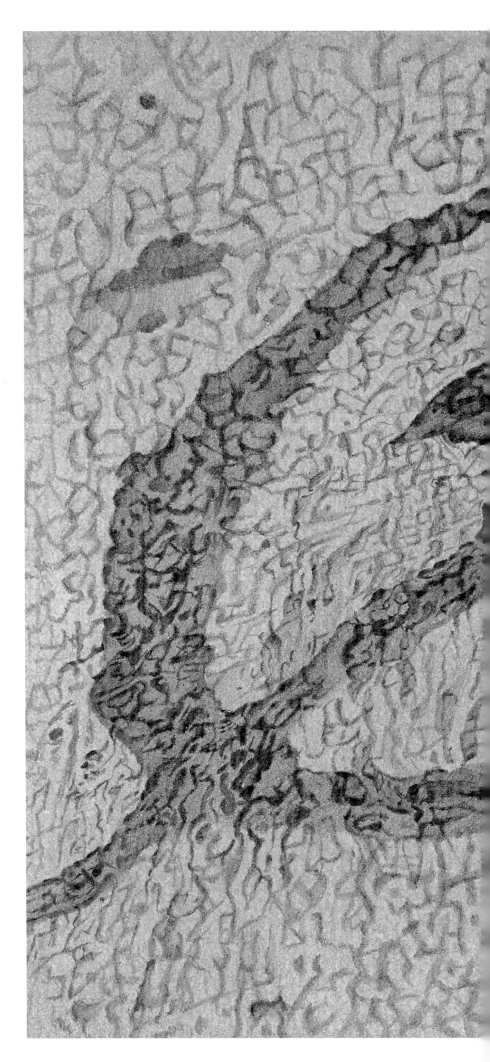

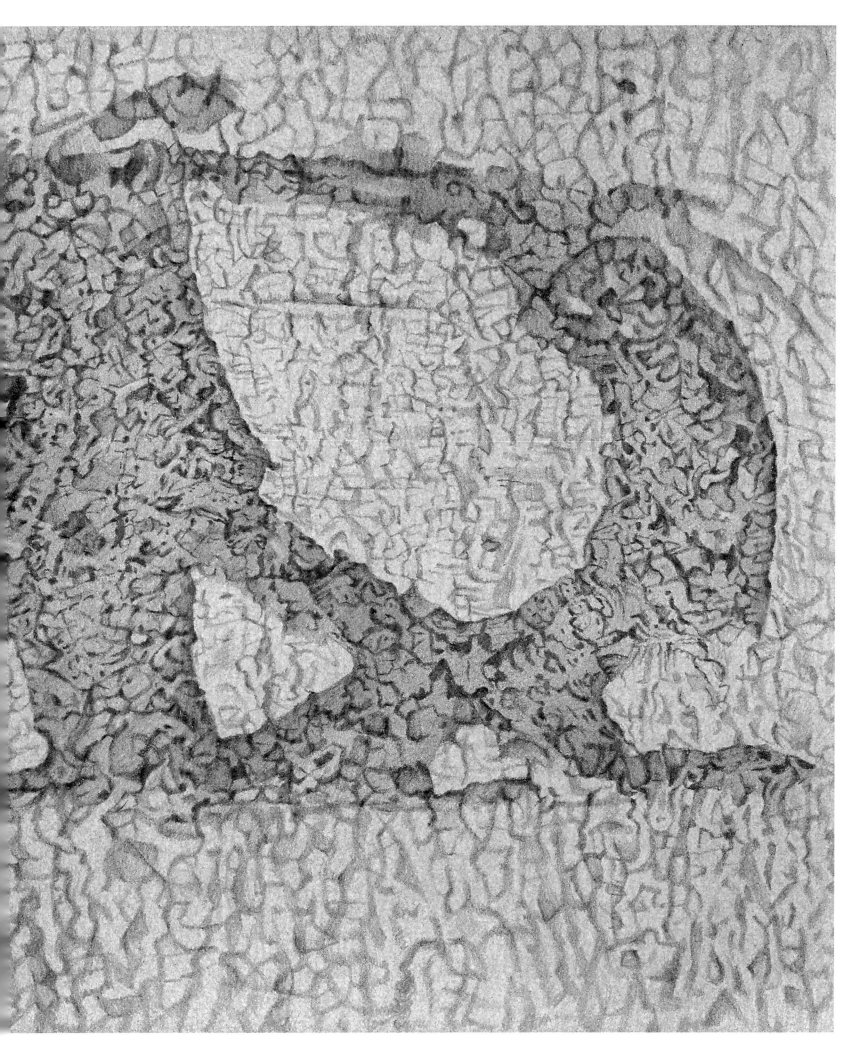

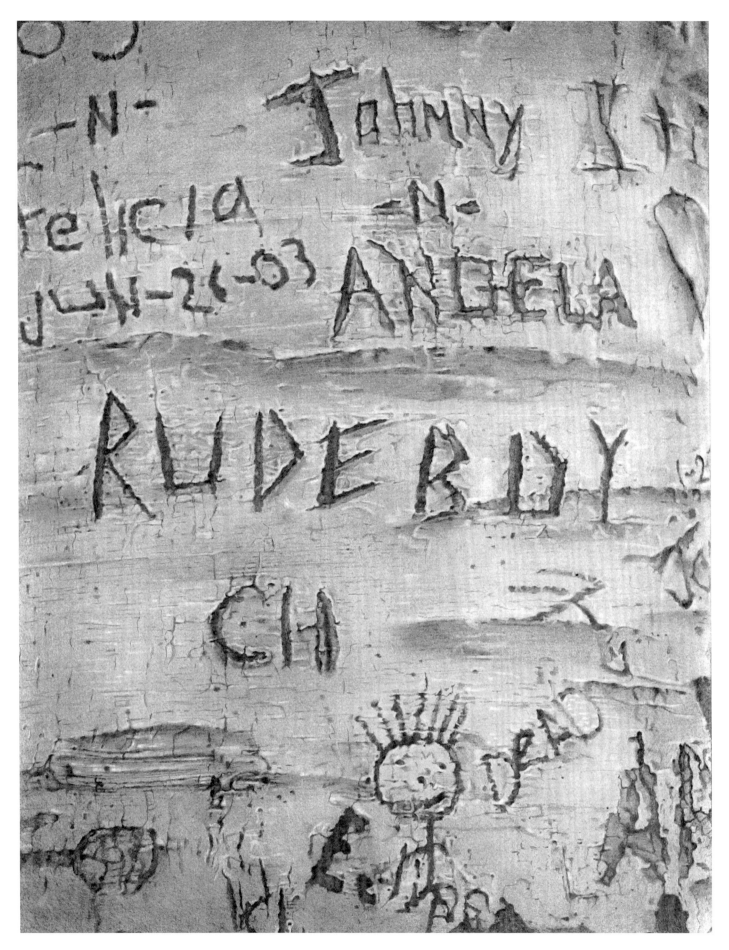

Rude Boy
Alley Pond Park
13.5" × 18" / 2010

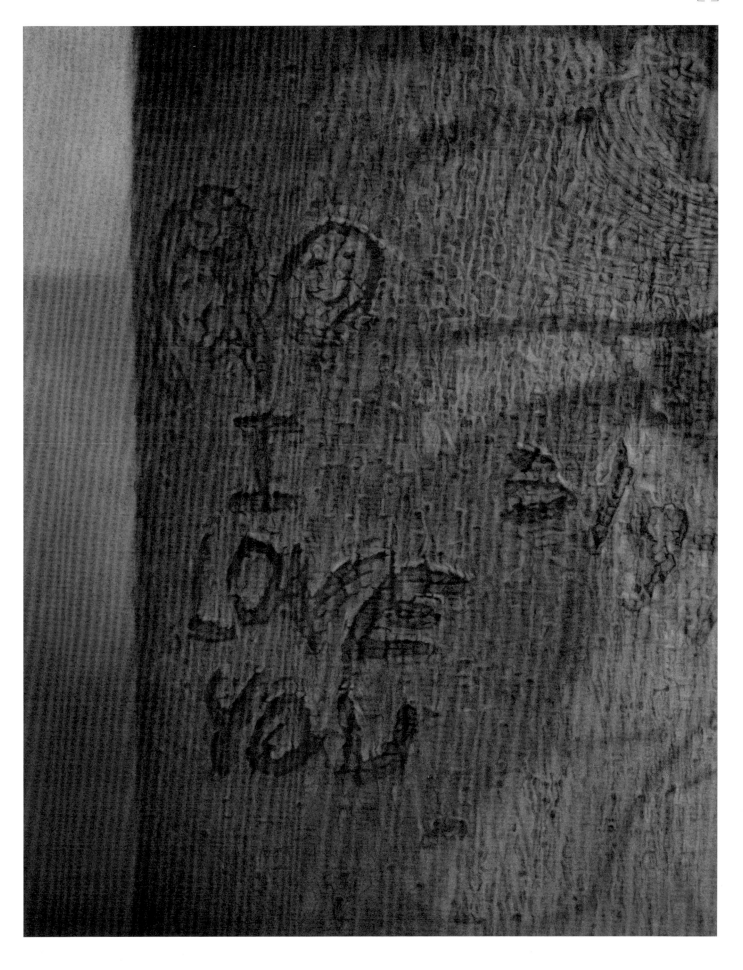

Boy and Girl
Alley Pond Park
9' × 11.5' / 2010

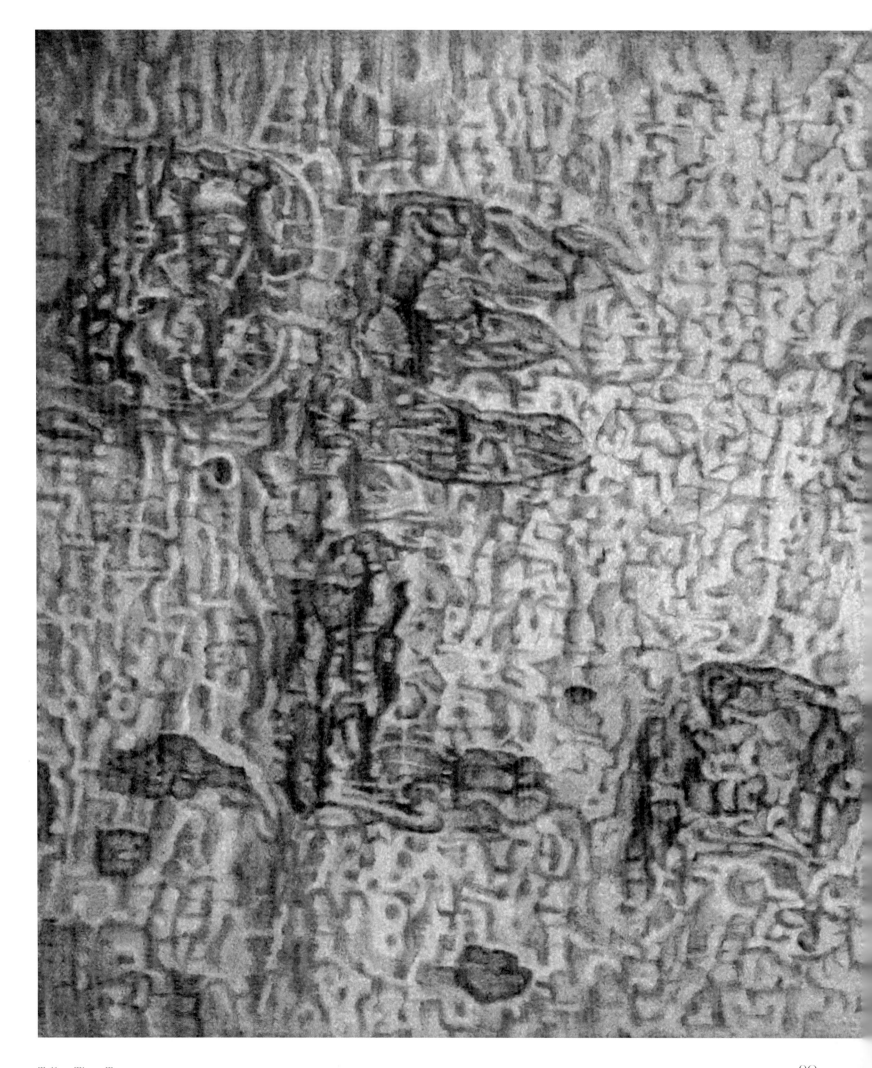

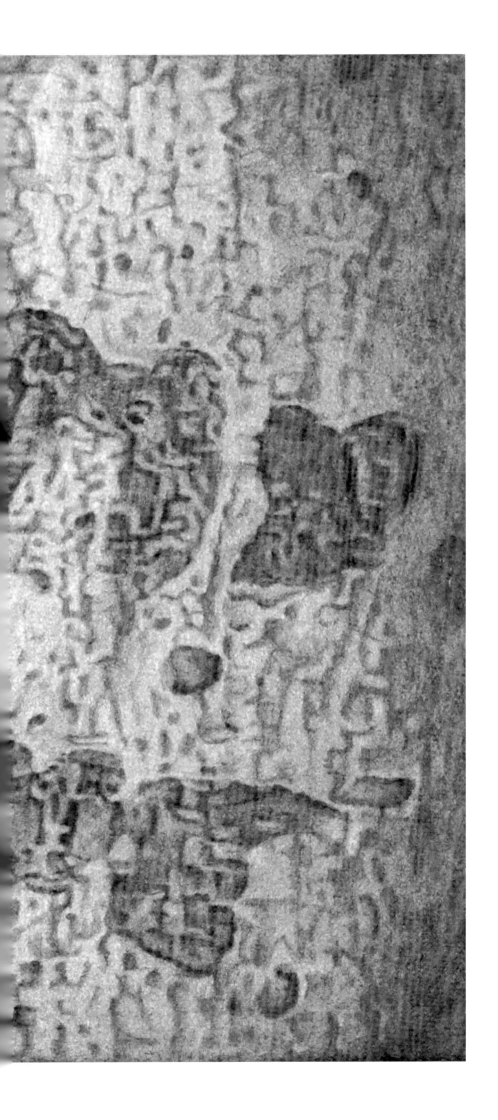

Graffiti Tree 2, Love
Alley Pond Park
13.5" x 10.75" / 2010

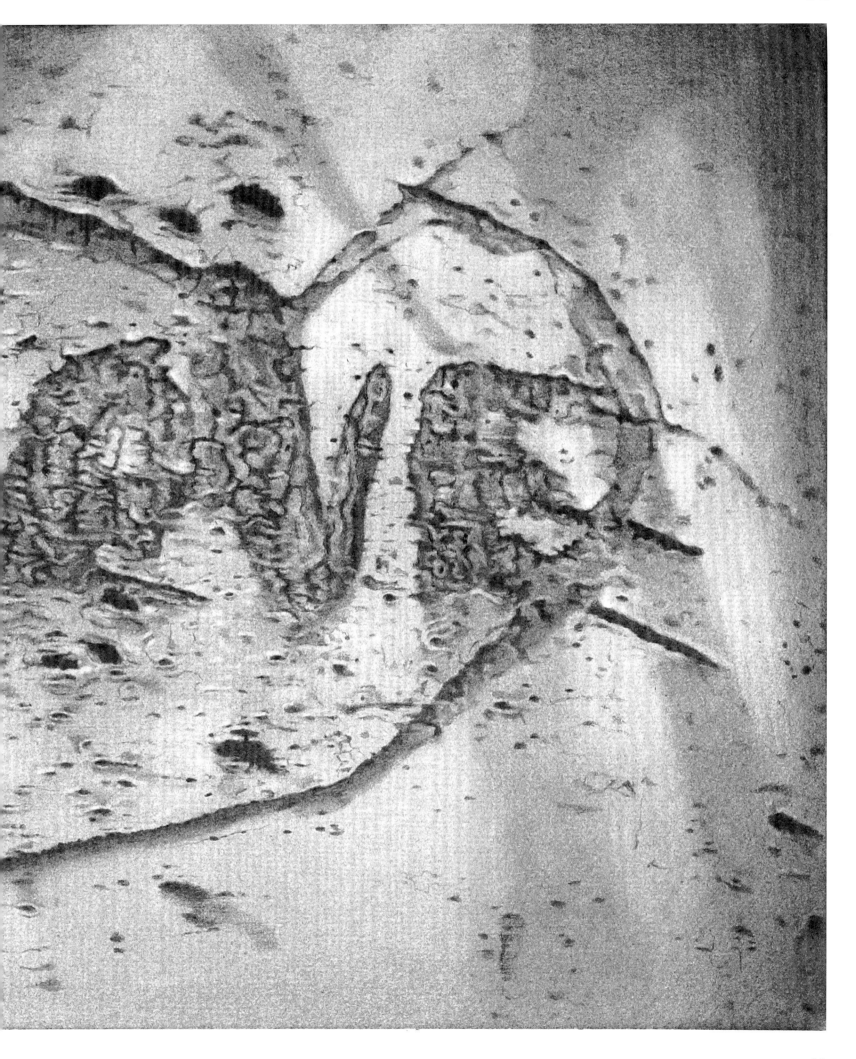

Graffiti Tree 1
Alley Pond Park
38" × 50" / 2008

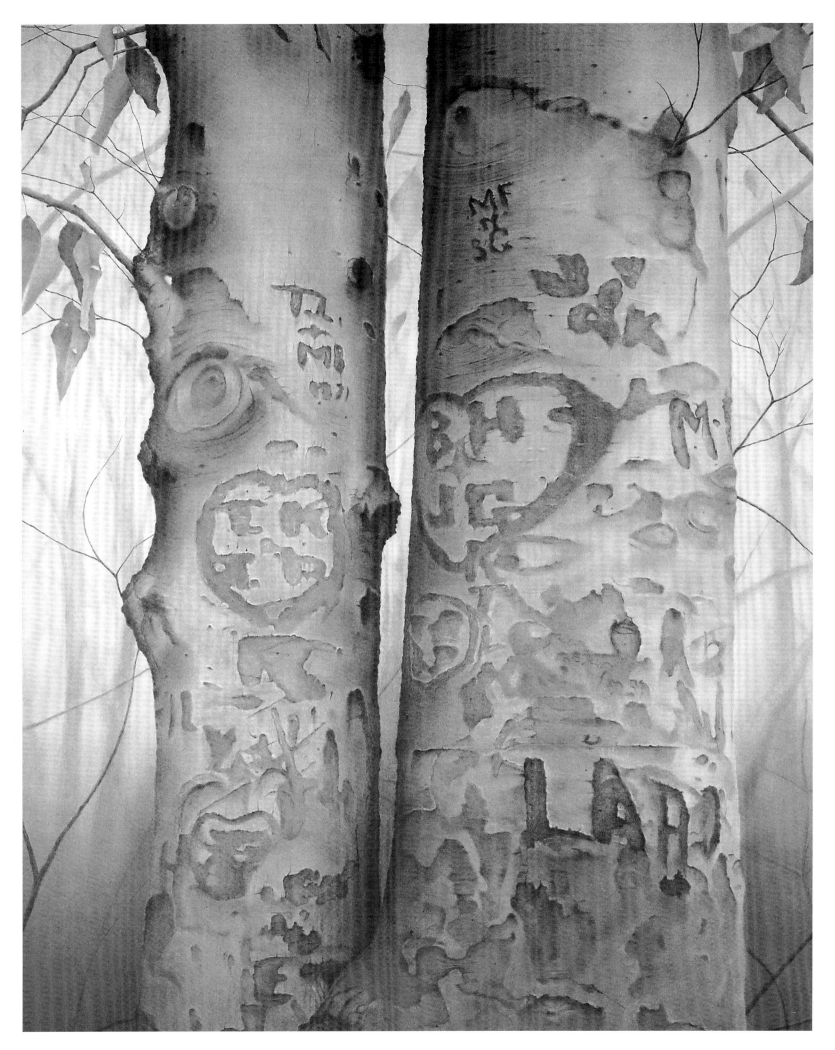

Taller Than Trees

Nobody

says it's pretty here; nobody says it's easy either. What it is is decisive, and if you pay attention to the street plans, all laid out, the City can't hurt you. I haven't got any muscles, so I can't really be expected to defend myself. But I do know how to take precaution. Mostly it's making sure no one knows all there is to know about me. Second, I watch everything and everyone and try to figure out their plans, their reasonings, long before they do. You have to understand what it's like, taking on a big city: I'm exposed to all sorts of ignorance and criminality. Still, this is the only life for me...Do what you please in the City, it is there to back and frame you no matter what you do. And what goes on on its blocks and lots and side streets is anything the strong can think of and the weak will admire. All you have to do is heed the design—the way it's laid out for you, considerate, mindful of where you want to go and what you might need tomorrow.

— *Toni Morrison, Jazz*

Brooklyn

Chapter / 03

Brooklyn is a beatnik's proud lullaby, an immigrant's enclave, an escape from so-called "maddening Midtown." Like Manhattan's skyscrapers—where compact office buildings surge upward and onward—Brooklynites fit their picnic blankets into a maze of cloths. Young men play basketball and handball in McCarren Park—Domino, Marine, Sunset—like they have since the '70s. Lifelong residents and rookies are intoxicated by Brooklyn's worthy haze, and its necessary crossroad from the metropolis.

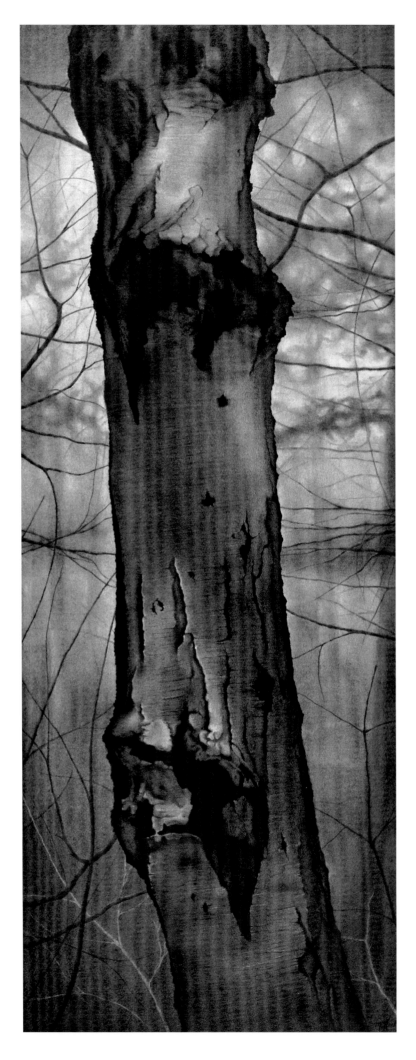

Taller Than Trees

Brooklyn Woods 1

Even those who feel special as they prowl Brooklyn's sundry sidewalks—at home, singing loudly in the shower, unheeded by a neighbor's proximity, or writing the next Great American Novel—is humbled in Prospect Park. Any power that is felt on the city streets is brought back down to earth in the Ravine, an Adirondack outpost and Brooklyn's only forest.

All you can own is your blanket, and your inner thoughts and aspirations, but never the patch of grass below. Grounded on the ground, taking root, you are one blade of grass in a rightfully cherished park. This place is a sacred vacation from the day's needy clutch, a chance to be anonymous in the urban throng.

Brooklyn Woods 2

Why do all parks acquire a magical and magnetic quality after dusk?

Perhaps it is a longing for star-gazing, or a will to hear the countryside's crickets, that draws New Yorkers to nature after hours. These suburban fantasies are happily sacrificed by those who love the City. At least the moonlight, as it bursts through a tree's branches, provides the feeling of adventure and mystery only found in the great outdoors. It shines brightly, as enigmatic as a neighbor's lit window seen from across the street.

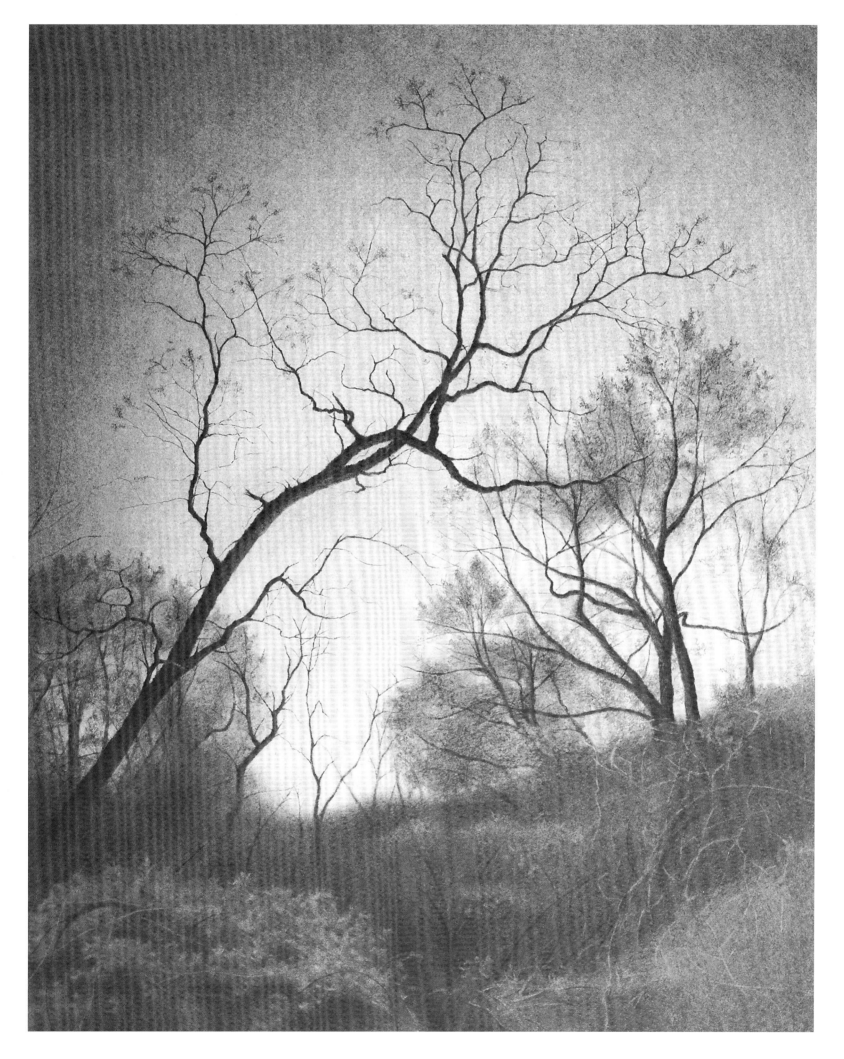

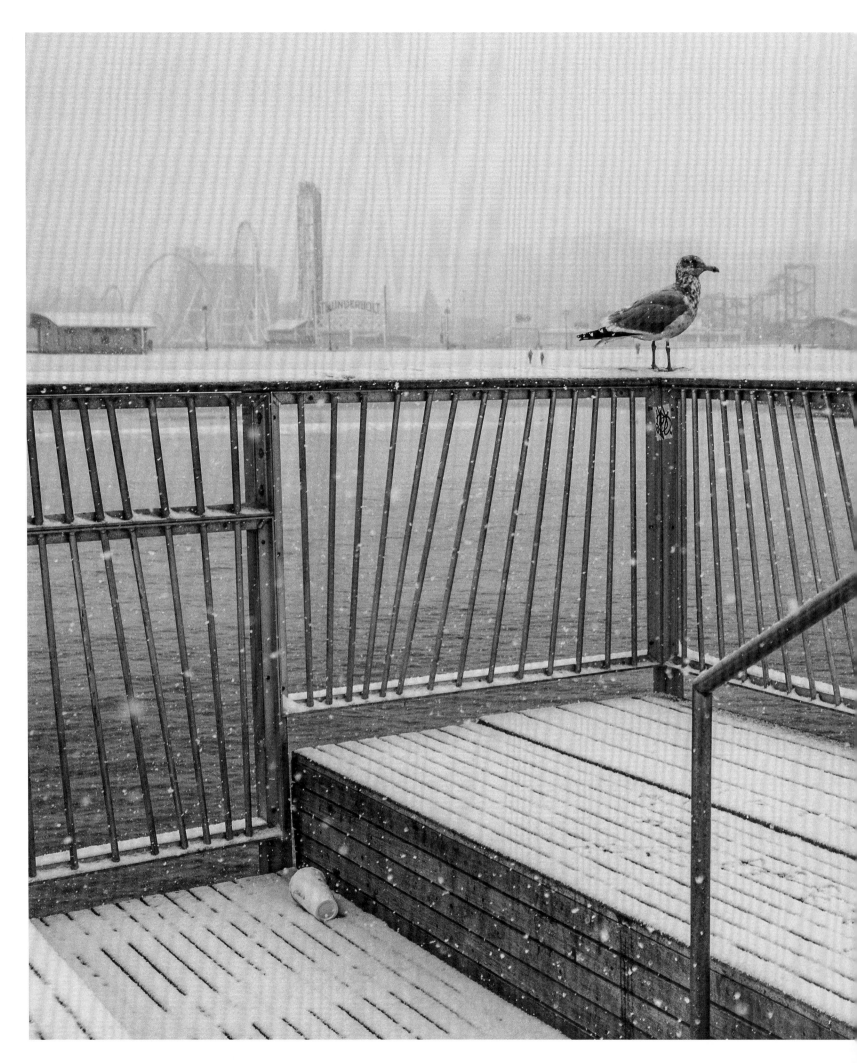

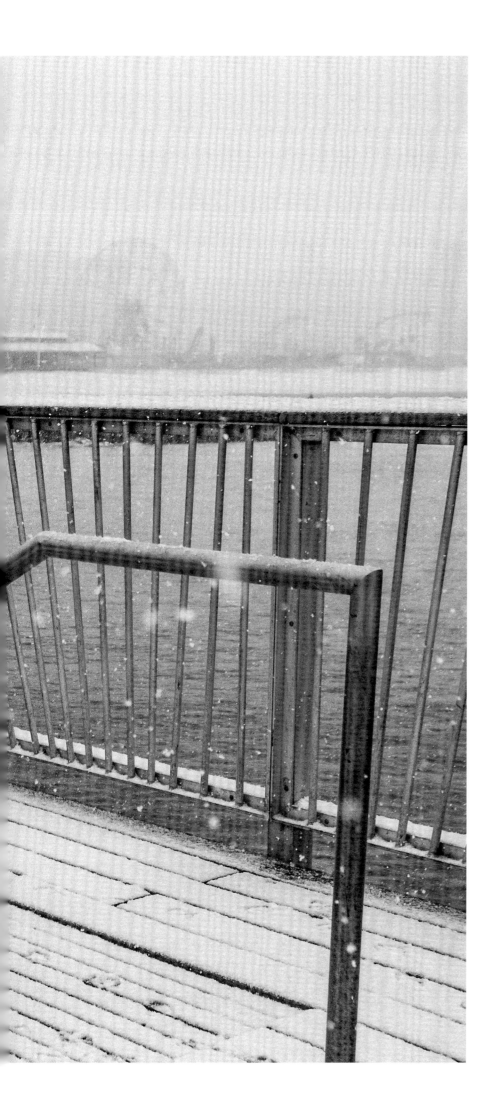

Seagull in Wintry Coney Island
Photographed by Luc Kordas

Man Feeding Seagulls
Photographed by Luc Kordas

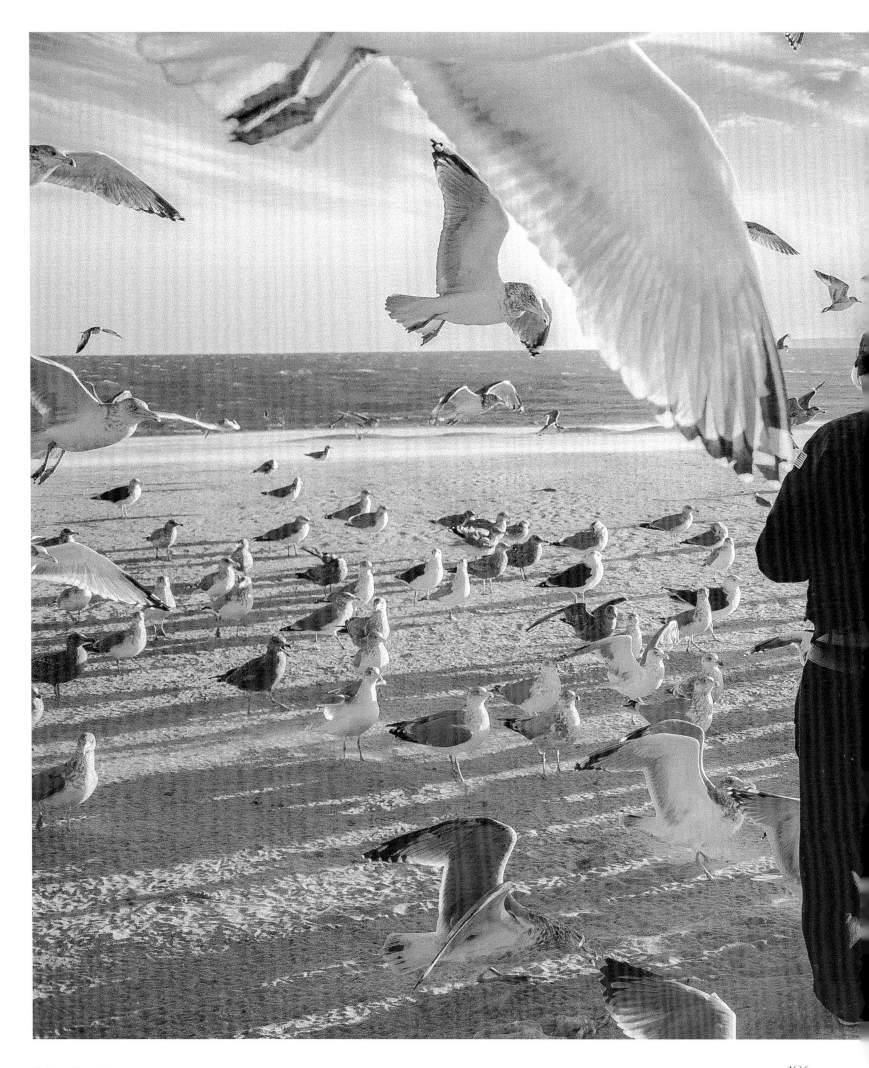

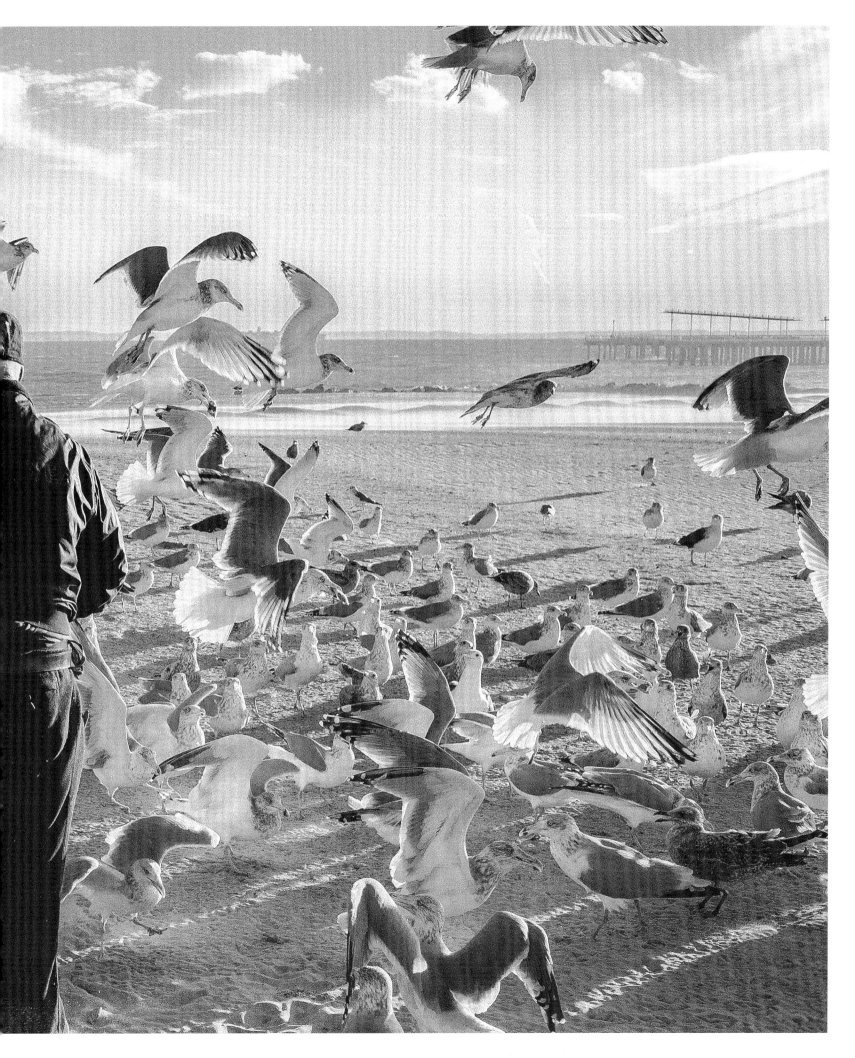

Brooklyn Bridge
Photographed by Jean-Andre
Antoine

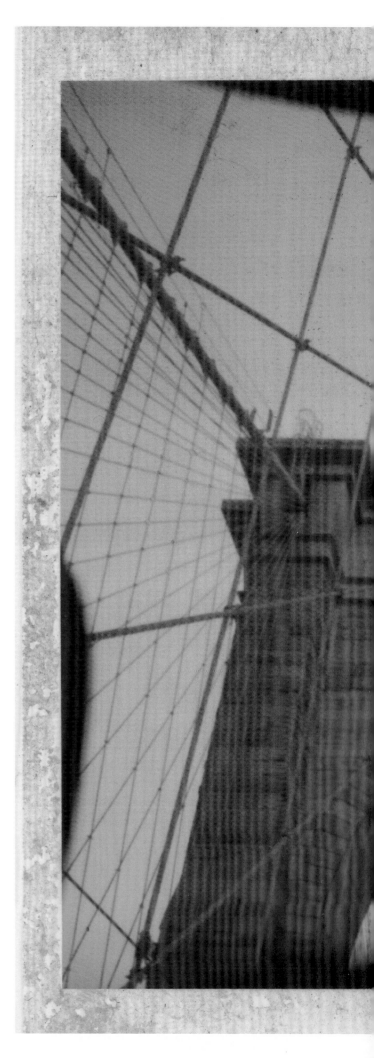

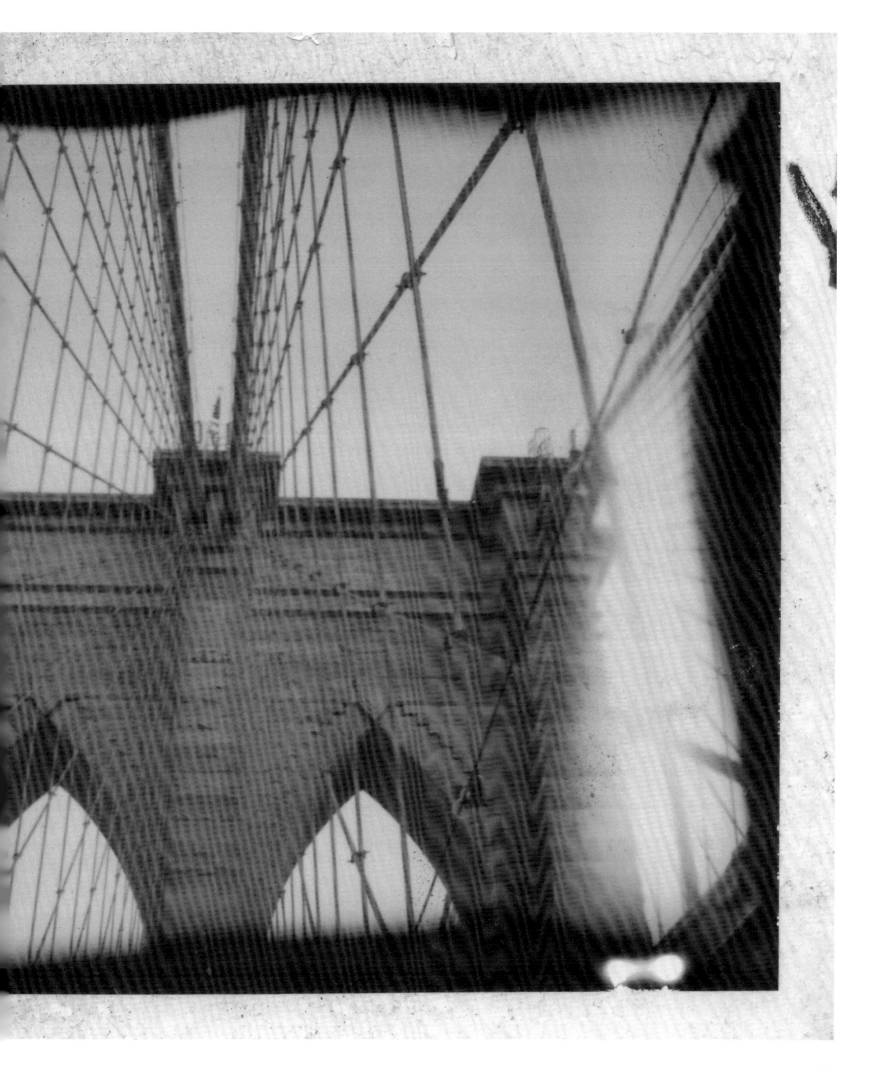

Bronx

Chapter / 04

Up here, from a lime green fire escape, life in the Bronx looks the same. At forty, your love for the rumbling Grand Concourse and rolling Bronx river is all the same, both urban arteries that deliver their passengers to the edges of riverbanks and on to shady patches of grass. From a picnic in Pelham Bay Park or from the shade of a bodega's awning, children bloom on bikes and skateboards, adolescents find themselves in the beats of hip hop, and ancient trees brood over it all, resiliently reaching for the sun each day.

PeeWee
New York Botanical Garden
Collection of New-York
Historical Society
10.75" × 13.625" / 2015

Peewee

Walking through the Thain Family Forest in the New York Botanical Garden, Reilly photographed and drew the trees that surrounded her. This garden, located in the greater Bronx Park, was modeled after England's Royal Botanic Gardens, constructed in Kew in 1888. And yet, despite its British undertones, New York's own natural oasis has a special, modern significance. It is acclaimed by the New York community and symbolic of extreme beauty found off the beaten path.

 PeeWee is the only work in Reilly's *Graffiti Trees* series outside of Alley Pond Park in Queens.

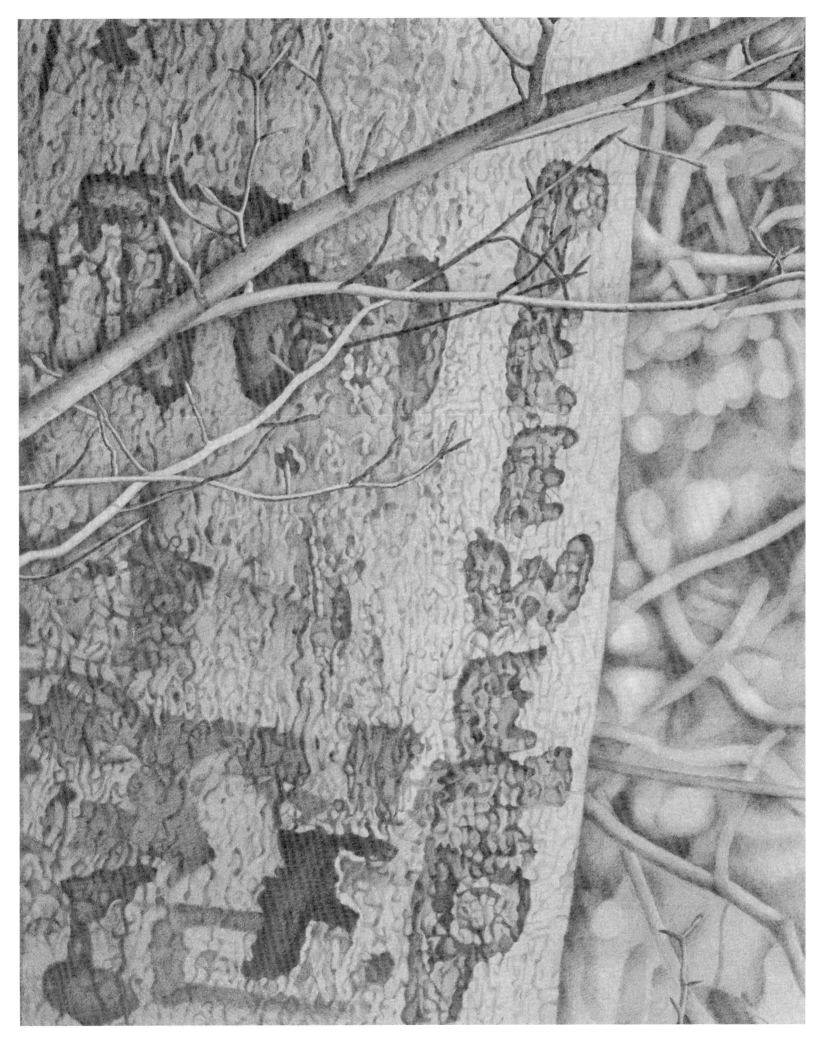

Bronx River
New York Botanical Garden
50' × 38' / 2006

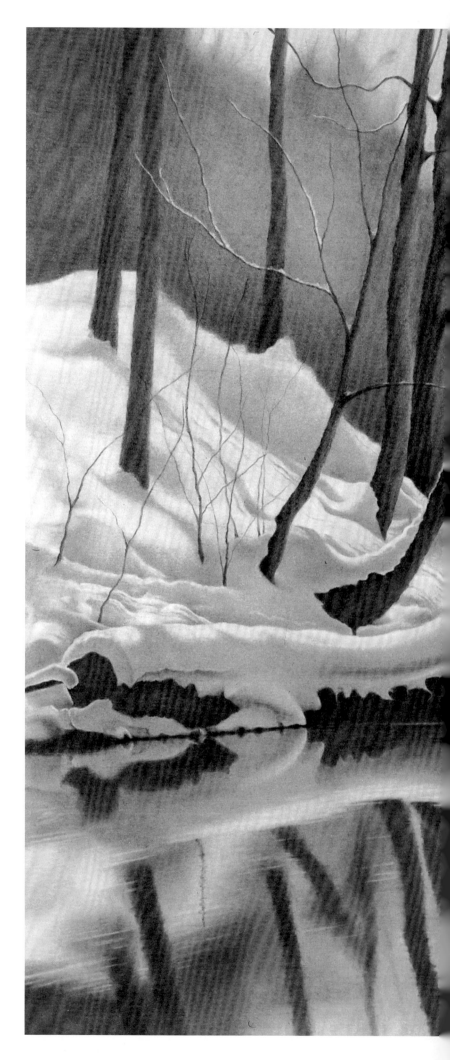

Bronx River

To march in three feet of fresh snow, where a thin layer of new ice is frozen atop, is like crunching large meringue cookies between your teeth and letting the sugar thaw. Snow makes the imagination whirl.

The Bronx River Greenway is a ribbon of green space spanning the river from Westchester County to the Bronx. In the case of this river, a history of pollution turns pure. Like the fresh snow, residents witness and participate in the redemption of their expansive land. They give wildlife a chance to come back.

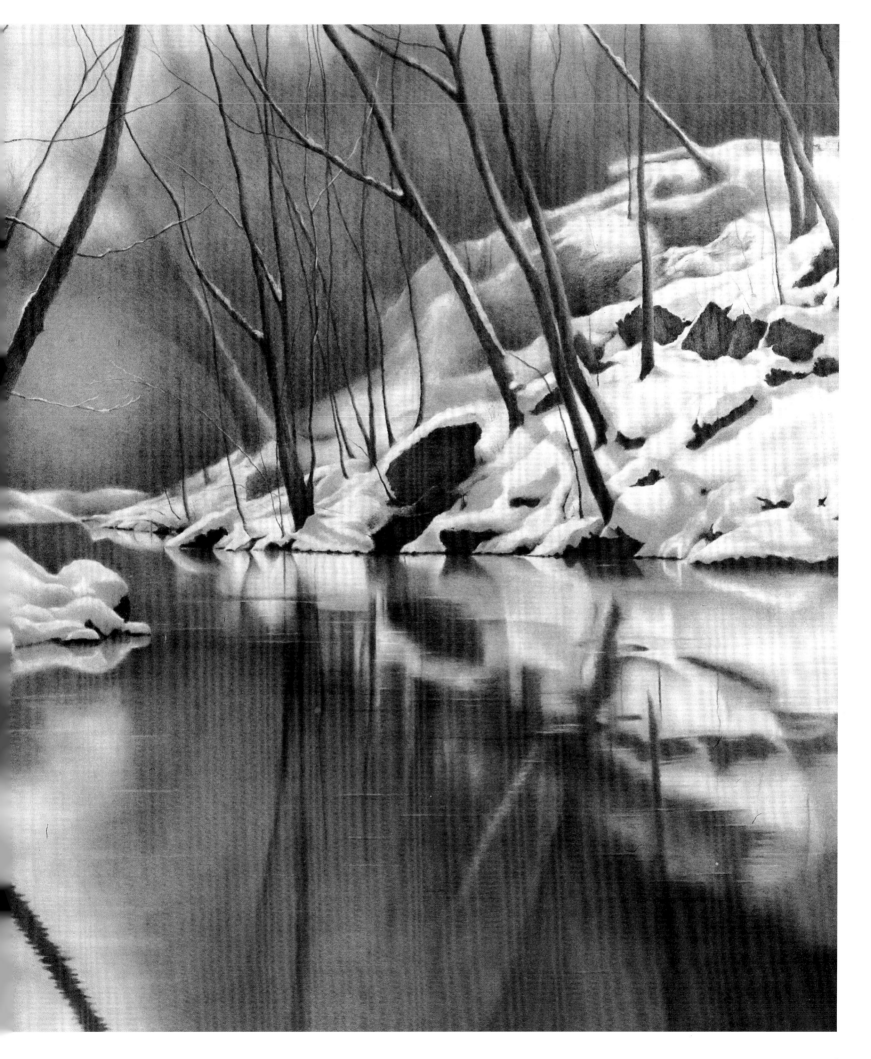

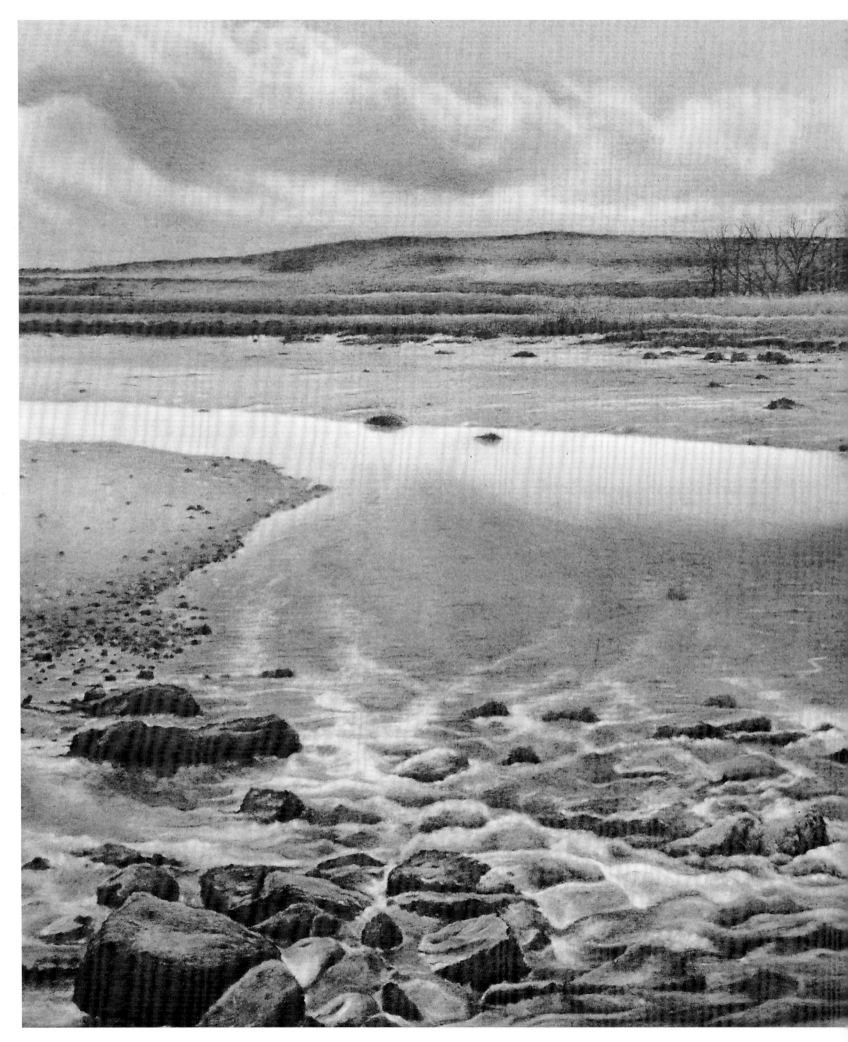

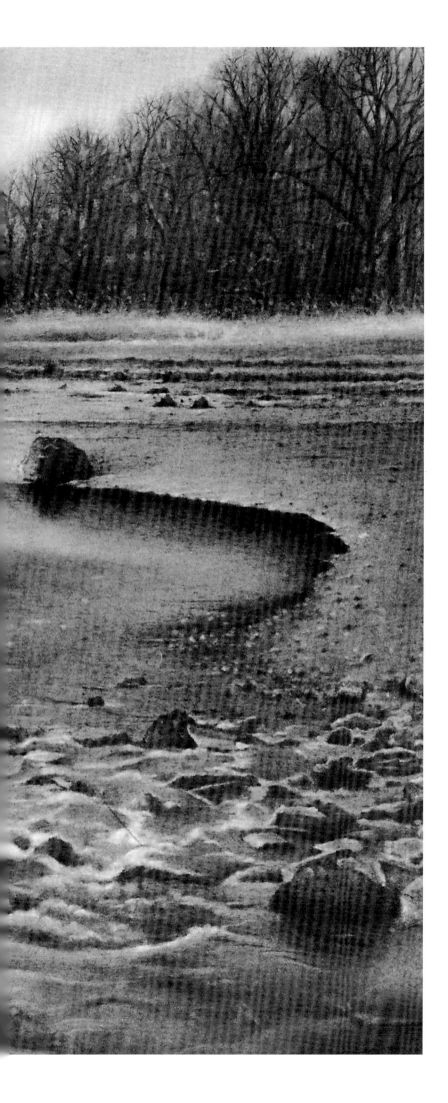

Pelham Bay
Pelham Bay Park
Collection of Bronx Museum
of the Arts
23.5" × 18" / 2010

Pelham Bay Park

Lying between Hunter Island and Orchard Beach is a salt marsh. It's muddy and beautiful. Standing on the land bridge bound by Turtle Cove, the rush of the water is slight and sound. Brown prickly plants, straw-like or thorny, bead the blue sky. When the trees are orange and it's early evening, the lagoon looks black and teal, and inky rocks poke up, half-concealed. Invisible fish swim, and you are invisible too.

Snow Branches
New York Botanical Garden
18" × 23.5" / 2011

Following Page:
Spring
Photographed by Luc Kordas

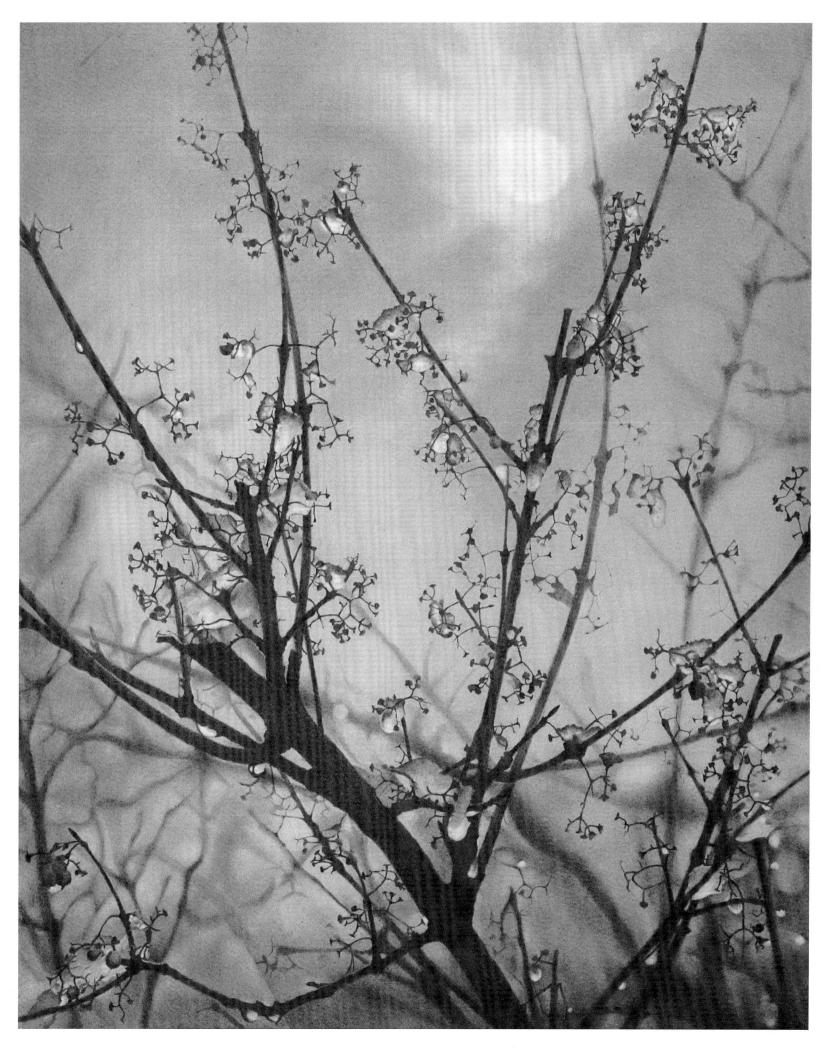

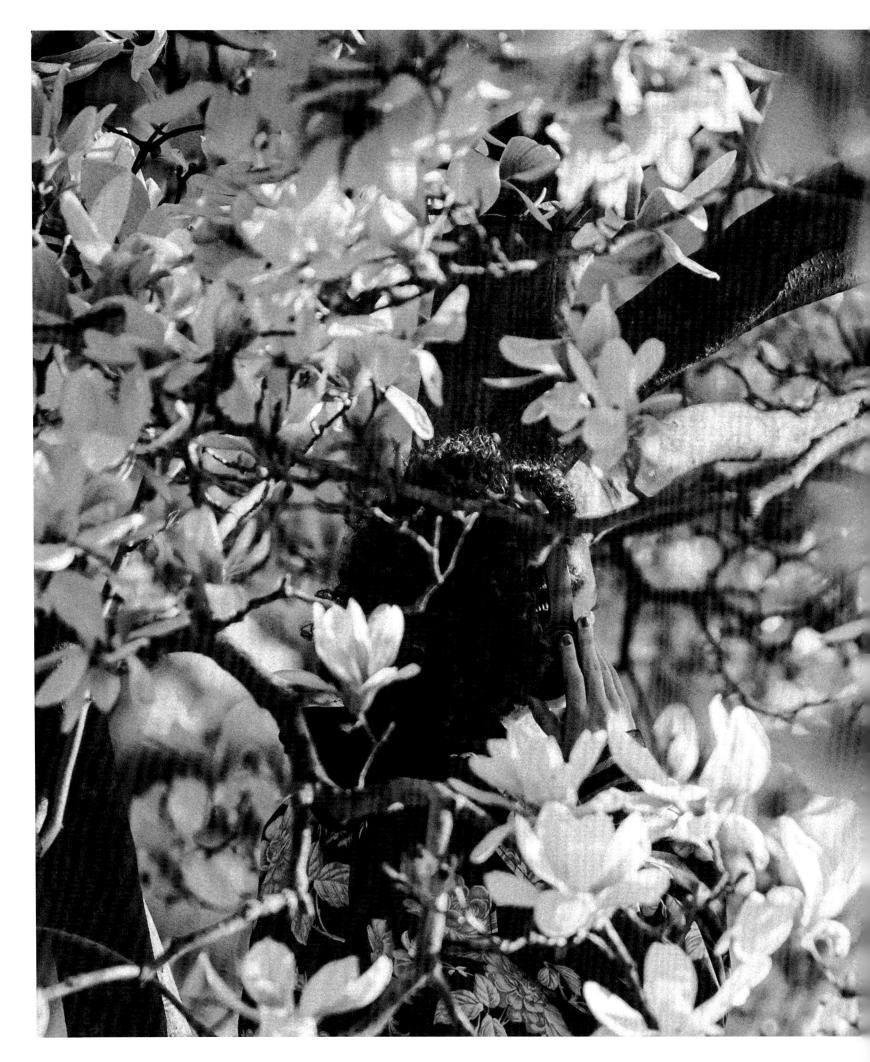

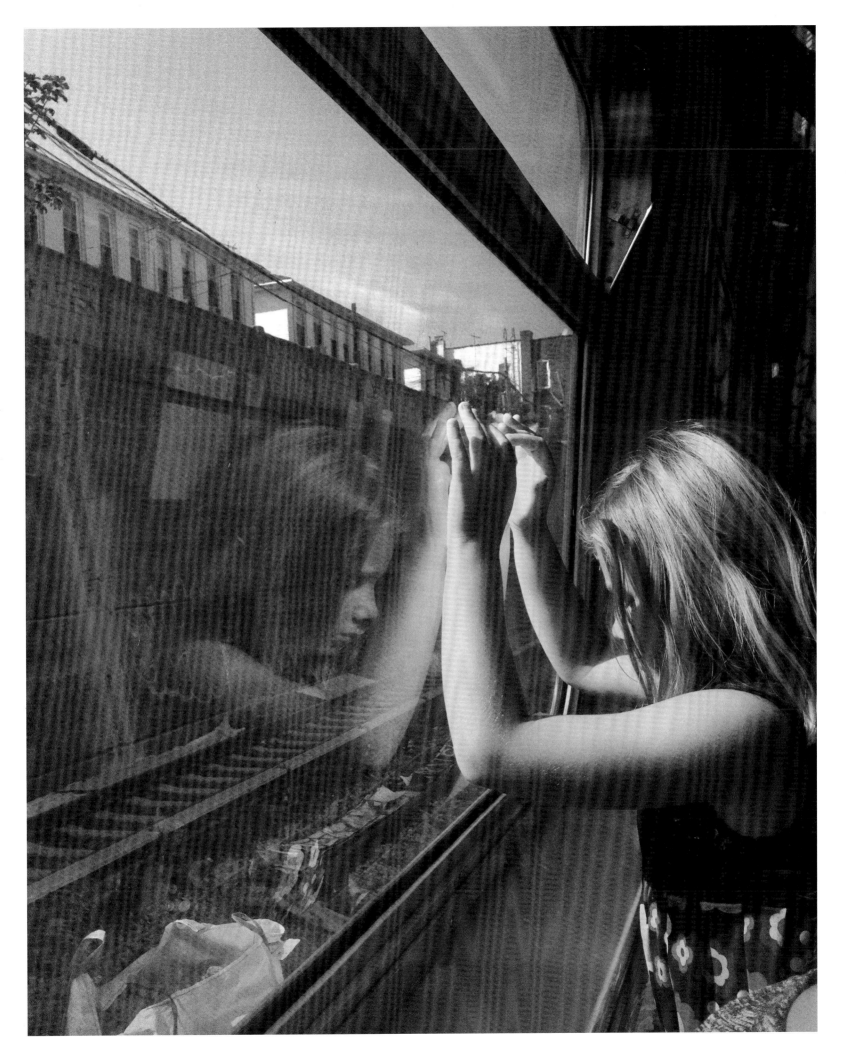

Staten Island

Chapter / 05

Waves crash onto the North Shore of Staten Island, where the heroes live. They descend the Verazzano Bridge's mighty shadow and meet the heels of city gazers. The blue bay is a reflection of the sky. There is seafood. There are soft shell clams, blue mussels, hermit crabs, and other native species dancing through the sand. They wear shells because they are strong. Sunbathers and swamps populate the land, and tall flowers break through tall grass. An organic strength radiates from the island—every citizen and structure just rocks and rolls, and outweathers your greatest tempest.

Moonrise
Blue Heron Park
38.125" x 28" / 2007

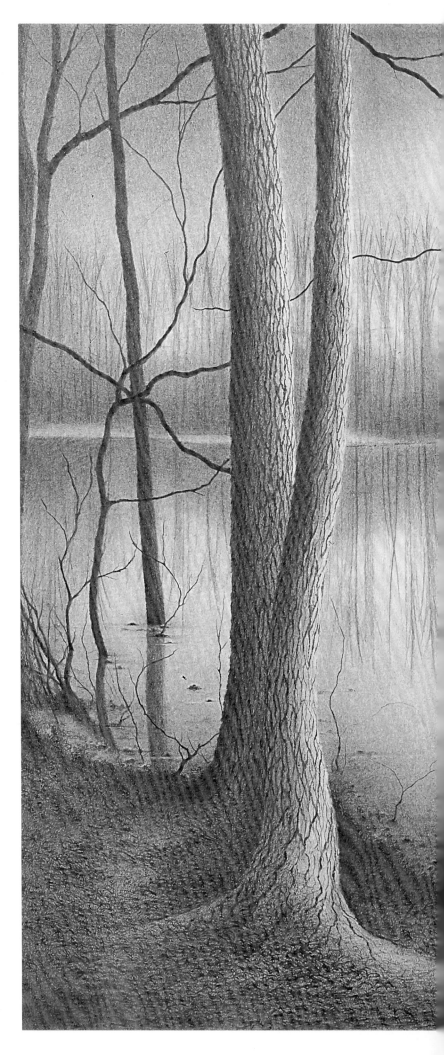

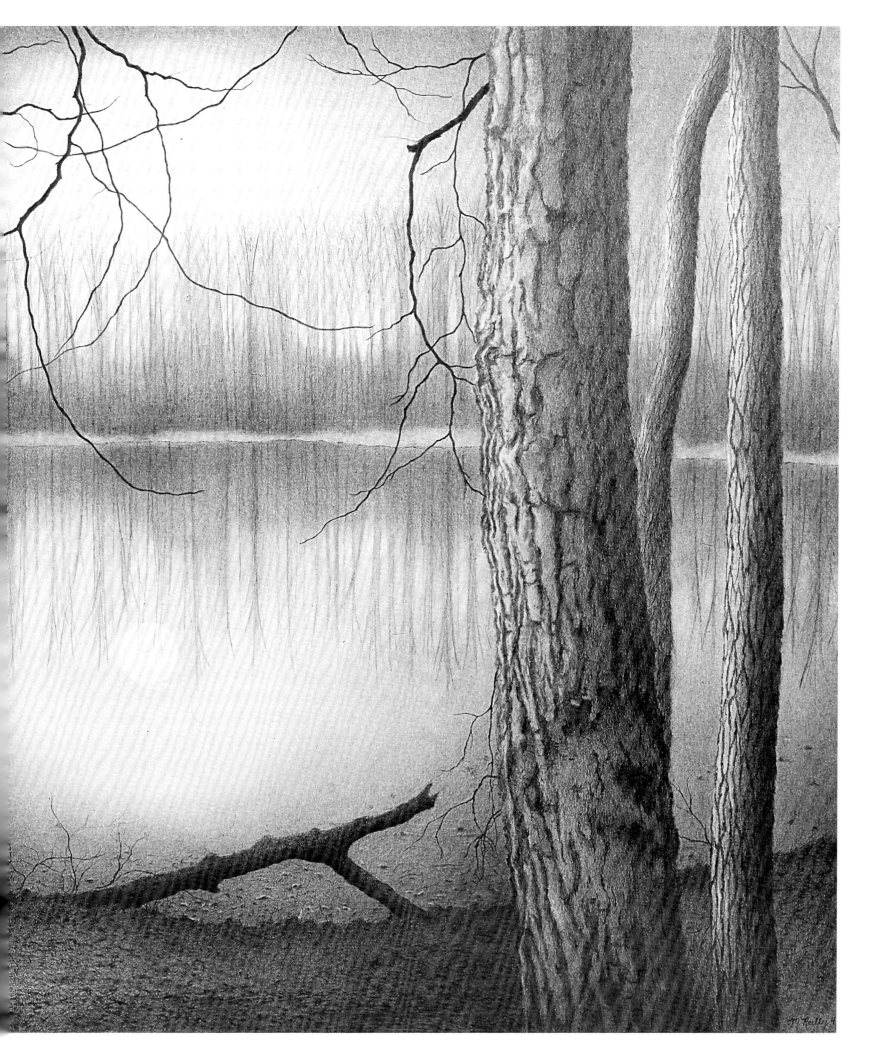

Memories of a Staten Island Childhood

Excerpt by Tim Kelleher

Spring Pond
Blue Heron Park
18' × 23.5' / 2007

It is a rare person who hasn't experienced the mystic bond between memory and the senses. How, for example, a certain smell can, like a time machine, transport us instantly to a place, and moment, in our past.

Five senses are what we're meant to have. New York, as it happens, is a city of five boroughs. Having lived in them all, I often am "returned" to each, though none more often than that "forgotten" one.

It all began when my grandparents left the Emerald Isle of Éireann to cross the Atlantic in hope of better prospects. Years later, my parents and I set forth from the Bronx, and made our way by ferry to the emerald island of Staten. As my grandparents no doubt did, we stared in windswept awe as the boat passed Lady Liberty. The memories to which our senses connect us may seem random, but actually are pieces of a mosaic we can assemble. And while the picture formed tells a story of its own, it also points, like an icon, to a treasure beyond.

When it comes to that sense of smell, there is one that is pervasive enough to be the olfactory canvas of my youth. Laugh if you want, but it's bubblegum: the reminiscence of schoolyard and street. Not just any kind either, for this, as did so many things, came in a pair of good options. In this case, *Bazooka* and *Double Bubble*. A choice was required; a kind of commitment that helped define you: *Converse* or *Keds*; *Giants* or *Jets*; *North Shore* or *South*.

The soundtrack of those years was a familiar mix: the Beatles, Hendrix, the Jackson 5, and lots of gold in between. But there was another, more elemental, backdrop; a blue-collar orchestra of iron and steel, whose music was the clanging hooks of docking ships, the rattling roar of anchor chain, the bells of buoys, gently bobbing on dark green harbor swells.

There was the wheezing of garbage trucks, hydraulic mastodons, prompted forward by tooth-whistle to the next group of cans. Sometimes that whistle came from where we hid, causing the truck to advance, and a crewman to dump half the can onto the street. For some reason, they never seemed to find that as hilarious as we did.

There were referee whistles, that trilled the frozen air of Travis Field, and hothouse hoops at Port Richmond's C.Y.O. Sirens of every kind, at every hour, that held the day together like wire around the bales of *The Advance*, tossed from trucks, then delivered from yellow sacks slung grimy across our shoulders.

From our home in Tompkinsville, you looked diagonally right and saw the Verrazano; left, and your eyes filled with the Oz of the Manhattan skyline. A quick bounce up Victory Boulevard, and you came to Clove Lakes Park, whose stone boathouse and trees, like maidens bent to their reflection at water's edge, seemed a Constable painting come to life.

Two images from those parks still transport me: the hexagonal paving stones across from Stapleton Library— the ones uniform throughout the city, from Central Park to Prospect, from Van Cortland to our own Tappen Park—lead to a sanctuary, in the shadow of the projects, where I fell in love with reading. The other is the image of the single leaf, outlined in white on a field of green. An emblem of Robert Moses' stealth empire, it suggests *Many leaves, One tree*, and links each park to every other in the City of New York.

Nothing, however, returns me more fully, or directly, to the heart of Staten Island than the brilliant melancholy of the foghorn—especially while running, when with earnest mantras rising in frost-clouds from your lips, you notice dusk's curtain reach the floor, the last streetlight flickered on, and still you were not home.

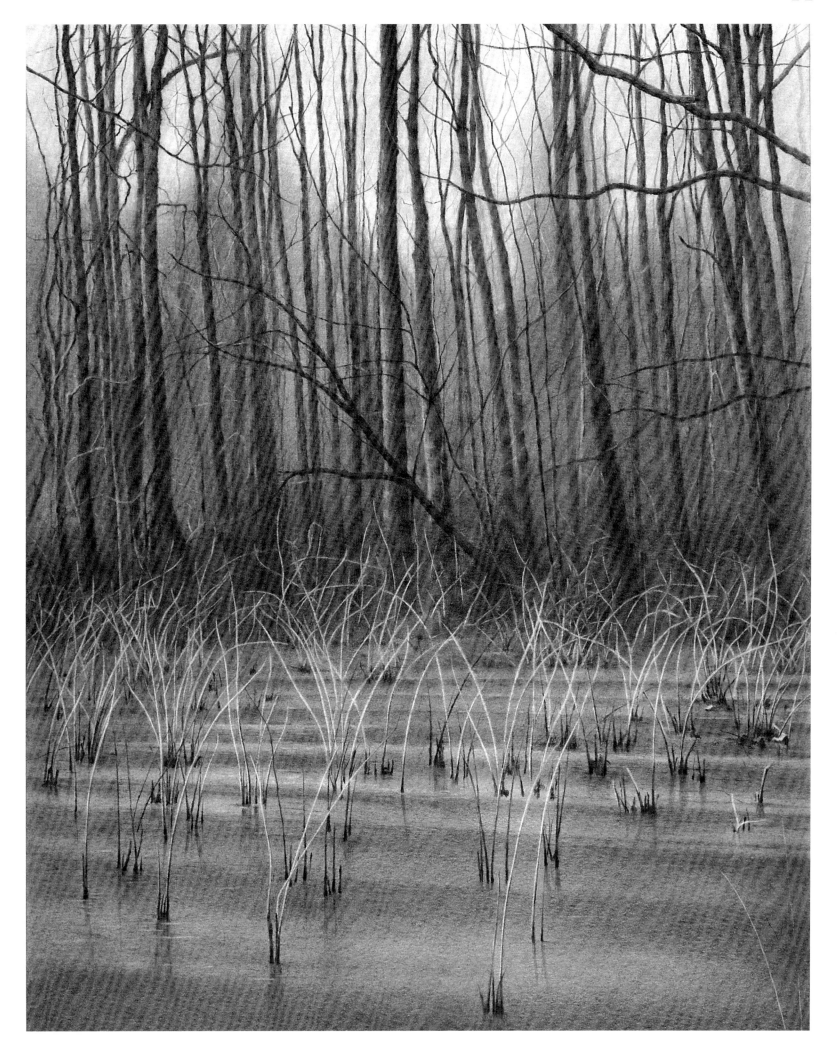

Clove Lake

Clove Lake represents our duality. Named after the Dutch word *kloven*, meaning *cleft*, the lake is divided, as is this larger city.

Everyone calls New York "authentic," and certainly this is true. Its authenticity is undeniable when you're walking past brownstones in Williamsburg or biking along the Bronx River Greenway. And yet New York changes very fast; its true form is hard to hold. After all, this same authenticity was described in the *Gothamist* and the *Post*, so how real could it be?

New York's identity is half-baked, and also a five course meal. The city forges and forgets its best work overnight, with the exception of a few twenty-four carat landmarks and each outdoor oasis.

Any true New York is caught between the real and the aspirational, as they pass from metropolis to meadow. Any true New Yorker thinks about that too much. But you need not think of this while at Clove Lake.

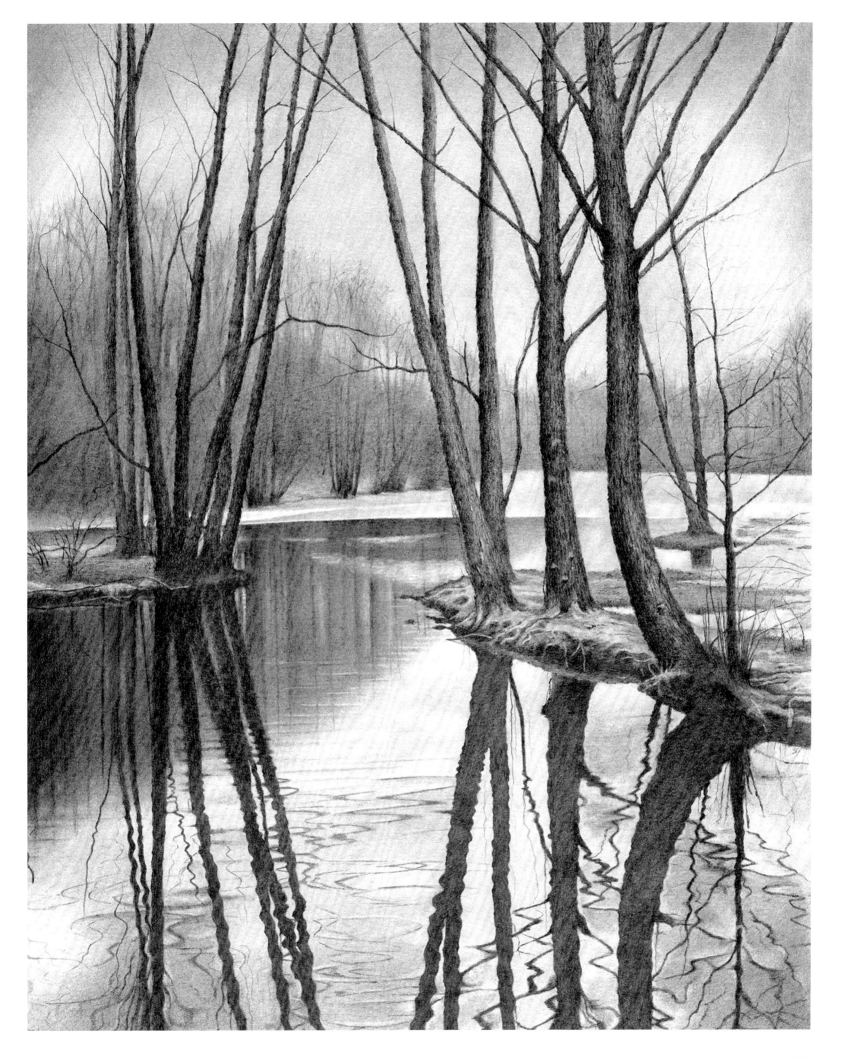

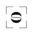

Shoreline

If you inhale the cool air on the northeastern beach, and watch the beach grass shiver and cattails dance while the doting ocean waves chat you up, you'll feel like a teenager. You'll feel on the precipice of something greater than yourself, this great city, or this greater ocean tide.

Approaching Manhattan
Photographed by Jean-Andre
Antoine

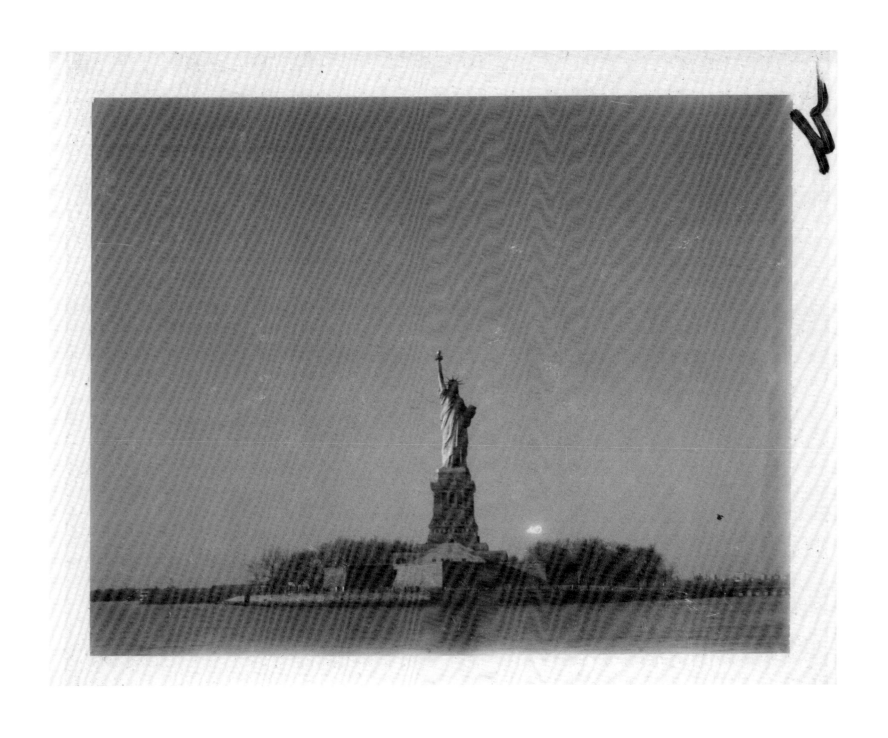

Statue of Liberty
Photographed by Jean-Andre
Antoine

They

were country people, but how soon country people forget. When they fall in love with a city, it is forever, and it is like forever. As though there never was a time when they didn't love it. The minute they arrive at the train station or get off the ferry and glimpse the wide streets and the wasteful lamps lighting them, they know they are born for it. There, in a city, they are not so much new as themselves: their stronger, riskier selves. And in the beginning when they first arrive, and twenty years later when they and the City have grown up, they love that part of themselves so much they forget what loving other people was like—if they ever knew, that is."

— *Toni Morrison*

Q&A with Mary Reilly

How did art play a role in shaping your life and identity?

Like most children, I loved to draw, but it was when I was a teenager that I started to recognize in myself how creating sharp details with graphite pencils felt so innate. I can only describe it as feeling a burning desire to draw the way I do now, using sharp detail in contrast with the soft patina of graphite. That need to draw was so strong that it became my identity, as well as being a mother to my two daughters. But I knew that drawing was what I was meant to do.

I first focused on drawing nature when I started spending my summers in Prince Edward Island, where I was surrounded by beautiful remote landscapes for which I felt such an affinity. Then during the year in New York City, I would walk through the parks looking for comparable images that had a tranquil, isolated and slightly mysterious quality to them as well. It's an expression of how I feel when I'm in nature.

What did depicting nature in your art do for your personal experience in New York City?

When I started putting my New York City series together, I would travel to the wooded areas of the parks all over the five boroughs to take landscape photos, that I would then use as a guide for my drawings. That research enhanced my experience of living in New York City, by opening my eyes to all of the majestic beauty within New York that I would probably have never seen otherwise. There are ancient forests in New York, a lot of people don't know that.

Looking back on your Graffiti Trees series, what do you think is the long-lasting meaning of beautiful park environments in city life?

I found all of the parks that I visited in New York City to be transporting, as nature just does that to us, and each park does have its own personality. Though I will say, the woods in Alley Pond Park transported me in a unique way. As I walked through those woods, almost every tree had markings on it. Some were faceless initials, within hearts, dating back to the 1930s and probably left by lovers taking a stroll. Some, I imagined, were left by kids from nearby neighborhoods hanging out smoking and drinking. Many of them were very amusing. As I walked through those woods, history spoke so loudly. It was almost a ghostly feeling to be surrounded by history, personalities and tradition. I felt an everlasting beauty in that park.

Describe the feeling of falling in love (with a person or a passion) in New York. What is one moment of personal growth that you had in New York City, or your experience of what it means to be a young person with ambition in the city?

I certainly felt a strong devotion and passion for creating both my New York City and Graffiti Trees series and for me, that was what was behind my ambition. It felt like an exciting adventure every time I visited and photographed a new park. It felt like a sense of discovery, much like the first time you go somewhere new on vacation. I can't speak of one particular moment of personal growth but rather an accumulation of growth.

Why did you choose to include the photographic work of Luc Kordas and Jean-Andre Antoine in **Taller than Trees?**

Both Kordas and Antoine's work have a mood to them that I felt complemented my work so well, and provided a new artistic medium depicting the beauty of the city's nature, as well as its eternality. For example, Antoine developed photographs of contemporary city scenes on film dating to the early 1940s. In an interesting way, that mirrors the timelessness of my *Graffiti Trees* series: like

Antoine's film, the trees themselves hold memories across decades of time.

The moodiness of Kordas' work drew me in, in his ability to capture ephermeal facets of nature, like fog, angels of individual snowflakes, and even the feeling of nighttime itself, beyond just the dark sky. In creating my work, I draw gray outlines then darken or lighten where needed, and that same contrast is apparent in Kordas' artistic celebration and reverance of New York's nature, as well.

What do you want New Yorkers and readers at large to take from **Taller Than Trees?** *How do you think or hope your art will touch them?*

My intention in *Taller Than Trees* is to illuminate the fact that New York City is more than bustling streets and neighborhoods. Its parks are a New Yorker's repose, a way to get away from their home and work environments, and to just simply be in nature. The parks are their "backyard", their personal outdoor spaces, though profoundly communal.

I hope that both *Taller than Trees* and my art show readers how glorious the nature of New York City truly is.

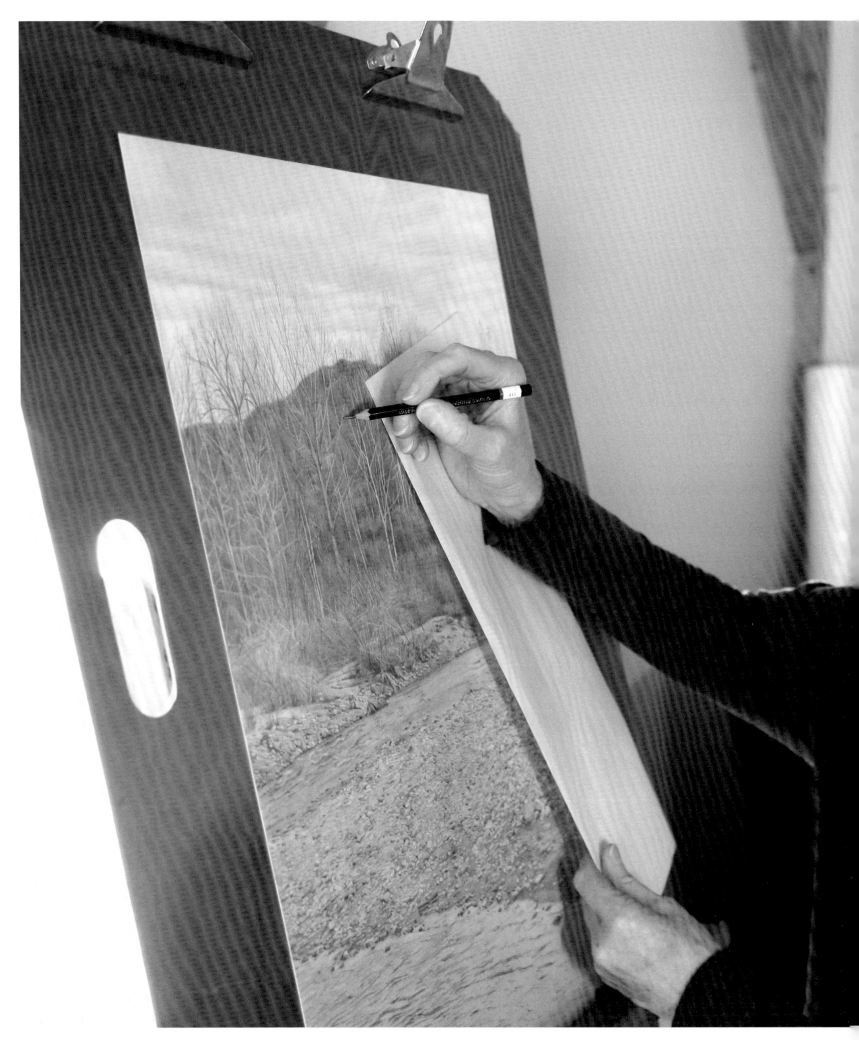

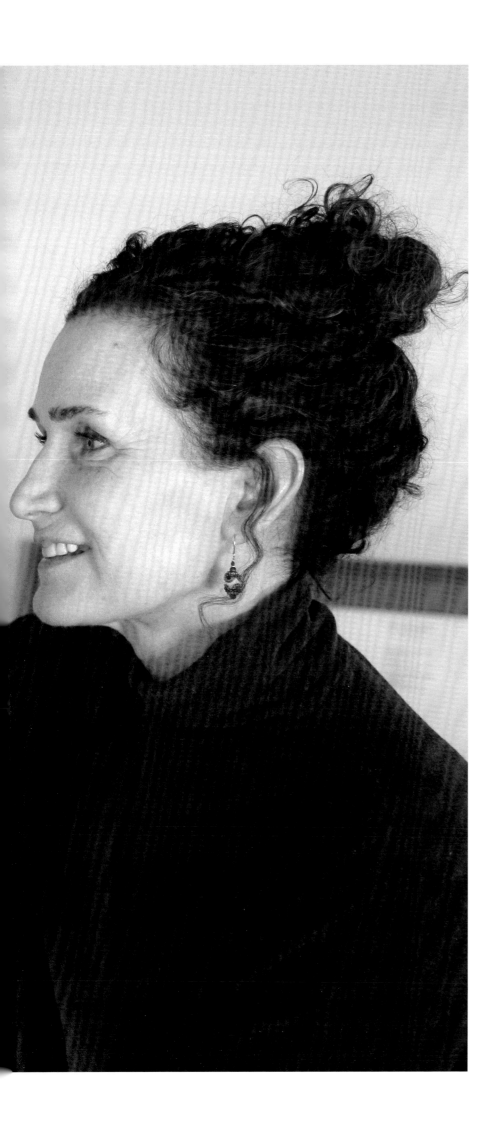

Mary Reilly
in her Vermont studio, 2021.

Many Thanks

To Elizabeth Garvey at Garvey/Simon NYC and to Rick Davidman at DFN Projects. Roberta Olson, Luc Kordas and Jean-Andre Antoine. Aya Abitbul and Nathalie Friedman at Studio 96 Publishing. Frederick Brosen. Michael Heeney Photography, Glenn Moodey Photography and Glenn Castallano Photography. Catherine Miller, Meredith Miller, Jeff Miller, Carol Reilly, Ed Morvillo, Robert Miller, Pat and James Nolan, Tom and Donna Reilly, and Kevin Reilly.

Taller Than Trees

© 2021 STUDIO 96 NYC
STUDIO 96 NYC, INC.
32 W 39TH ST., 4TH FLOOR
NEW YORK, NY 10018

FIRST EDITION PUBLISHED © 2021

HELLO@STUDIO96NYC.COM
WWW.STUDIO96NYC.COM
INSTAGRAM @STUDIO96NYC

ISBN 978-1-7363266-8-8

FOR MORE STUDIO 96 RELEASES AND UPDATES,
SUBSCRIBE TO OUR NEWSLETTER AT:
STUDIO96NYC.COM/SUBSCRIBE

FOR TEXT AND DIGITAL CONTENT
© STUDIO 96 NYC

FOR TONI MORRISSON QUOTES
© PENGUIN RANDOM HOUSE LLC

FOR IMAGES
© 2021 MARY REILLY
© 2021 JEAN-ANDRE ANTOINE
© 2021 LUC KORDAS

PRINTED IN CANADA.